Nick Vandome

Smartphone Photography

in easy steps

covers iPhones and Android phones

In easy steps is an imprint of In Easy Steps Limited
16 Hamilton Terrace · Holly Walk · Leamington Spa
Warwickshire · United Kingdom · CV32 4LY
www.ineasysteps.com

Copyright © 2020 by In Easy Steps Limited. All rights reserved. No part
of this book may be reproduced or transmitted in any form or by any
means, electronic or mechanical, including photocopying, recording,
or by any information storage or retrieval system, without prior
written permission from the publisher.

Notice of Liability
Every effort has been made to ensure that this book contains accurate
and current information. However, In Easy Steps Limited and the
author shall not be liable for any loss or damage suffered by readers
as a result of any information contained herein.

Trademarks
iPhone® is a registered trademarks of Apple Computer Inc. All other
trademarks are acknowledged as belonging to their respective
companies.

In Easy Steps Limited supports The Forest Stewardship Council (FSC),
the leading international forest certification organization. All our titles
that are printed on Greenpeace approved FSC certified paper carry the
FSC logo.

MIX
Paper from
responsible sources
FSC® C020837

FSC
www.fsc.org

Printed and bound in the United Kingdom

ISBN 978-1-84078-901-0

Contents

1 Photos on Mobile Devices

Digital photography has evolved rapidly since the first digital cameras were developed. This chapter looks at how the smartphone has now become essential in the digital photography world.

The Changing Face of Photography

It is only a couple of decades or so ago that digital photography was the new kid on the digital block. The idea of capturing photos onto a memory card, using a collection of digital data rather than on traditional film was revolutionary at the time, but it quickly became popular with photography enthusiasts and the wider consumer market. The instant nature of digital photography was one of its great selling points: as soon as you took a photo you could see it on the camera, without the need to wait hours or days for a camera film to be developed and printed.

One of the initial drawbacks about digital photography was the expense of the digital cameras themselves. However, the technology advanced quickly, to the point where, within a few years, owning a digital camera was a realistic option for most people taking photos. As the popularity of digital photography has increased and become more widespread, we rarely think of it as a separate entity: digital photography is usually now considered simply under the banner of "photography".

Following the introduction of digital photography, the next big game-changer was the use of digital cameras on smartphones and tablets. This has had a significant impact on the way in which people deal with their photographic needs: in a lot of cases, the advantages of using a smartphone for taking photos has led many people to use this instead of a separate camera. The benefits of undertaking photography on a smartphone are numerous:

- **Convenience**. These days, most people keep their smartphones with them at all times. This means that they are also ready to take photos whenever they want.

- **Portability**. Smartphones are generally smaller than digital cameras and easier to carry around in a pocket, so that they are always to hand.

- **Two cameras**. Most smartphones have two separate cameras: one front-facing one and one back-facing one. The front-facing one is ideal for taking selfies (photographic self-portraits) – a craze that began with smartphones.

- **Sharing**. Smartphones are also ideal for sharing photos that have been taken on the smartphone. This can be done directly from a photo sharing/editing app, and most smartphones have their own default apps designed for this.

Don't forget

Although smartphone and tablet cameras are now very powerful and contain a range of options for photographic techniques and effects, they still do not offer the full range of options that are available on good-quality cameras. However, the gap is narrowing all the time, and the convenience of using a smartphone in particular is enough to make a lot of people favor them over using a separate device.

Default Camera Apps

Everything on a smartphone or tablet is done through the use of apps (short for applications), even taking photos. The default Camera app is used both on Apple iPhones using the iOS operating system and on Android smartphones. Think of the Camera app as the equivalent of turning on a traditional camera: once you tap on the app, the camera interface is activated. This includes the current scene being viewed by the camera, and the camera controls.

Camera

The top toolbar of camera apps usually contains the options buttons for items such as flash, self-timer, and filter effects.

The two main types of smartphones are Apple ones (i.e. the iPhone which runs on the iOS operating system) and Android ones, which can be customized to run on a range of different smartphone models – e.g. Samsung, Sony, Google, or Motorola. The iOS operating system is only used on Apple smartphones.

The bottom section contains the Shutter button, different shooting modes (including taking videos), and the Swap-camera button for switching between the front-facing and back-facing cameras.

Third-party Camera Apps

Although the default camera apps provided on iOS and Android smartphones are very capable and effective for taking a range of different photos, you are not constrained to only using the default ones: it is possible to download other camera apps that can be used instead (third-party apps). These generally have a greater range of functionality than the default camera apps, and so you will have more control over your photos. They are also useful for adding special effects to photos. To use a different camera app:

Hot tip

Some camera apps are free and others have to be paid for. Some of the free ones also have in-app purchases, where additional features have to be paid for. Try downloading a few free apps initially to assess their features and also to see how comfortable you are with the interface.

1 Access the relevant app store for your smartphone – e.g. the App Store for an iOS smartphone, or the Google Play Store for an Android smartphone

2 Enter **camera apps** into the Search box

3 Tap on one of the results to view its details

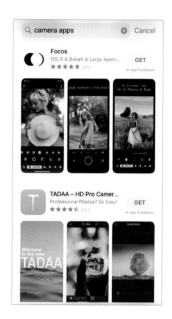

4 Tap on one of the apps to download it to your phone and use it for taking photos with your smartphone's camera

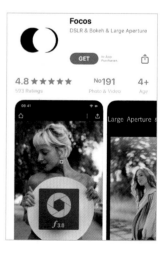

Accessing Camera Controls

Camera controls can differ depending on the model of smartphone and the camera app being used, but in general a lot of the functionality is the same:

1 Tap on this button (Shutter button) to take a photo

2 If the camera has different shooting modes, swipe left and right above the Shutter button to access them

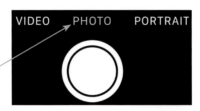

3 Tap on the thumbnail of the most recently taken photo to view it

4 Tap on this button to switch between the front-facing and back-facing cameras

5 Tap on the **Flash** button to view its options. Tap on an item to apply it for the flash

6 Tap on the **Self-timer** button to view its options. Tap on an item to apply if for the self-timer

7 Tap on the **Filters** button to apply a filter effect for the next photo to be taken

Don't forget

The Flash, Self-timer and Filter options are usually located on the top toolbar in the Camera app. The Shutter button is usually located at the bottom-middle of the Camera app.

Beware

If a filter effect is selected in Step 7, this will stay in place until another filter effect is selected, or it is canceled – i.e. the filter effect is set to None.

Accessing Camera Settings

For the default camera apps on Apple and Android mobile devices, there is a full range of settings that can be applied to the camera. Accessing these settings can vary between Apple devices (iPhones and iPads) and Android ones: on Apple devices the settings are accessed from the Settings app, and on Android devices they are accessed from the Camera app itself. Regardless of which type of device is used, these settings can be used to apply a range of options for the camera, such as for how video is captured, and displaying a grid over the window to help with composition in photos.

Apple camera settings

To access the camera settings for an iPhone or an iPad:

For Apple mobile devices the terminology is slightly different for smartphones (iPhone), and tablets (iPad), in terms of the operating system used. For the iPhone it is iOS and for the iPad it is iPadOS. However, the functionality of the two systems is virtually identical, particularly in terms of working with and managing photos.

1. Tap on the **Settings** app

2. Tap on the **Camera** option

3. Select the camera settings as required

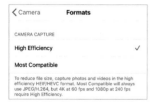

If an item in Step 3 has an arrow next to it, tap on it to access more options for the item.

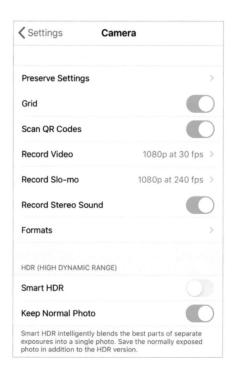

...cont'd

Android camera settings

To access the camera settings for an Android mobile device:

1 Open the **Camera** app and tap on the **Settings** button

2 Select the camera settings as required

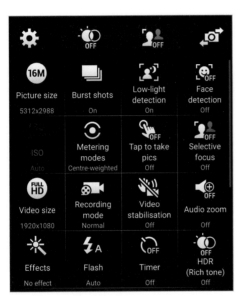

Hot tip

Third-party camera apps usually have settings that can be accessed from a button similar to the one in Step 1.

3 Tap on an item to access additional options for it

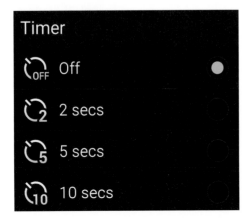

Smartphones and Tablets

Both smartphones and tablets have cameras that can take good-quality photos. However, there are some points to consider when choosing which device to use for your photographic needs.

Quality of cameras

Smartphone manufacturers have recognized that a good-quality camera is one of the features that helps their models stand out from the crowd. Also, as more people migrate to using their smartphones as their main photographic device, the need to make the cameras as effective as possible has increased. Therefore the quality and range of features of smartphone cameras has increased at a quicker rate than those on tablets. This is not to say that cameras on tablets cannot be used to capture some eye-catching photos, but smartphone cameras are a better option as a one-stop shop for most of your photographic needs.

Size

Due to their respective sizes, smartphones are a significantly better option in terms of photography, particularly if you are going to be anywhere other than your own home. Smartphones fit easily into a pocket or a bag, and they can also be held one-handed when taking photos. Tablets can certainly be used for photographic tasks too, but they are bulkier and less maneuverable, and it can become frustrating using them regularly to take photos.

Beware

Photo editing can be done effectively on a smartphone, but it is best to use a smartphone with as big a screen as possible, to ensure that you can see the editing effects.

Editing capabilities

In terms of size, viewing and editing photos is where tablets come into their own. The larger screens mean that they are an excellent option for viewing your photos clearly, and also showing them to family and friends, either individually or as an artistic slideshow, with transitions and music.

Best of both worlds

Apple smartphones and tablets and Android devices both have cloud services that can be used to ensure that you get the best of both worlds when taking, viewing, and editing photos: the photos can be captured on the smartphone and then backed up to the cloud service. Apple devices use the iCloud service for backing up a range of items including photos, and the Google backup service can be used with Android smartphones and tablets. For both of these services you need to sign in before you can start using them. To do this:

An Apple ID can be created during the setup process when you start using an iPhone or an iPad for the first time. It can also be created when you start using one of the linked services for the first time – e.g. the App Store for downloading apps. An Apple ID can be created with an email address and a password.

- For iCloud, create an Apple ID and tap on the **iCloud** button within the Settings app. If you access the iCloud button without having created an Apple ID, you will be prompted to do so at this point. See pages 16-17 for more details about using iCloud for photos. Once iCloud has been set up, tap on the **Photos** button to turn it **On** so that photos can be backed up to iCloud.

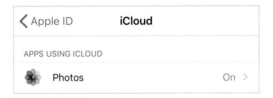

- For Android devices, you will sign in to a Google Account when you first start using the device. Then, photos can be backed up using the Photos app and the Google backup service. To do this, open the Photos app, tap on the menu button at the top of the window, and tap on the **Settings** option. Tap on the **Backup & sync** button to turn **On** the backup service for storing photos automatically.

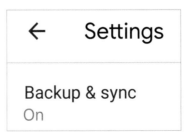

Both iCloud and Google Backup & sync offer free storage up to a certain limit: 5GB (gigabytes) for iCloud, and 15GB for Google Backup & sync.

Photos with Apple

Once photos have been captured on a smartphone or tablet, they can then be edited on the same device: for Apple devices, this is done with the default photo-editing app, Photos. This is the same app on the iPhone and the iPad.

Photos app and iCloud

When using the Photos app it is possible to link it to the iCloud service. This means that photos captured and edited on one device can be accessed on another device. This is done using the iCloud option in the Settings app and also the Photos option. To set up iCloud for using photos:

Buttons such as those in Step 5 in the Settings app can be turn **On** or **Off** by tapping on them. If the button in green the item is **On**.

By default, you get 5GB of free storage with an iCloud account. This can be used for photos and other items stored in iCloud. More storage can be bought, if required.

1. Tap on the **Settings** app

2. Tap here at the top of the **Settings** window

3. Tap on the **iCloud** button

4. Tap on the **Photos** button

5. Tap on the **iCloud Photos** button to turn it **On** and enable sharing photos within iCloud

...cont'd

To access settings for the Photos app:

1 Tap on the **Settings** app

2 Tap on the **Photos** button

3 The settings for the Photos app are displayed

4 iCloud Photos can be turned **On** in the same way as in Step 5 on the previous page

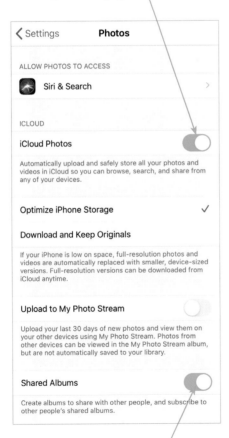

Hot tip

Tap the **Upload to My Photo Stream** button **On** in Step 4, to enable photos uploaded on one device to be viewed on another device, providing that they both use the same Apple ID.

Don't forget

Select the **Optimize iPhone Storage** option in Step 4 to compress the photo files to ensure that they use as little storage space as possible on your iPhone (full-size versions remain in iCloud). Select the **Download and Keep Originals** option to save photos on your iPhone at full size.

5 Tap the **Shared Albums** button **On** to enable other people to access albums that you have created (you have to also invite them to view the shared album)

...cont'd

Using the Photos app

The Photos app on the iPhone and iPad can be used to store, edit, and share photos. This is regardless of whether it is linked to iCloud or not (if it is linked to iCloud, photos from other linked devices can also be available in the Photos app). To use the Photos app:

Hot tip

Tap on a thumbnail image in the main Photos window to view it at full size. Tap on this button to go back to the main window in Step 2.

Don't forget

For more details about editing photos with the Apple Photos app, see pages 72-73.

1 Tap on the **Photos** app

2 Tap on the **Photos** button on the bottom toolbar to view all of the photos on your iPhone or iPad

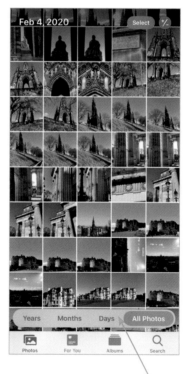

3 Tap on these buttons to view photos according to **Years**, **Months**, **Days**, or **All Photos**

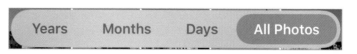

4 Tap on the **Albums** button on the bottom toolbar to view albums that have been created to store similar photos

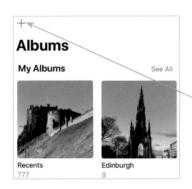

Hot tip

Tap on the **+** button in the Albums section to create a new album.

5 Tap on the **For You** button on the bottom toolbar to view collections of photos that have been collated automatically by the Photos app, such as featured photos and Memories

6 Tap on one of the **Memories** to view it and display it as a slideshow with transitions and music

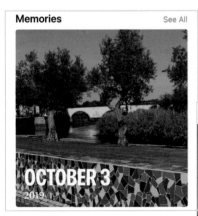

Hot tip

Tap on this button once a Memory has been accessed, to play it as a slideshow.

Photos with Android

Since smartphones and tablets using Android can be customized to a certain extent in terms of the apps being used, different photo apps can be available on different models of devices. However, for consistency, the Google Photos app can be used on any device that is using Android. The Google Photos app can be used to store, manage, edit, and share photos that have been captured on an Android smartphone's camera.

Downloading the Google Photos app

The Google Photos app will be pre-installed on some Android smartphones, but not all of them. If it is not, it can be downloaded, for free, from the Google Play Store. To do this:

Don't forget

The Android operating system is owned by Google, so their range of apps work effectively on Android devices.

20

1 Tap on the **Play Store** app

2 Enter **photos** into the Google Play Search box

3 Tap on the **Google Photos** app to download it

Google Photos
Google LLC
4.5 ★

4 Tap on the **Google Photos** app (named just **Photos** once it has been downloaded) to open it

...cont'd

Using the Google Photos app

Once the Google Photos app has been downloaded, if required it can be used to work with photos that have been taken with the smartphone's camera:

1 Tap on the **Photos** app to open it

 Photos

2 Tap on the **Photos** button on the bottom toolbar to view photos that have been taken, according to the dates on which they were taken. Tap on a photo to view it at full size

 Photos

3 Tap on the **Albums** button on the bottom toolbar to view and create albums for storing photos of similar type

 Albums

Hot tip

If the Photos app is not immediately visible on the Home screen of the Android device, it might be found in the Google folder, or from the **Apps** button.

Apps

Hot tip

In the Albums section, tap on the Menu button to access options for creating a new Album or a new album for sharing with other people.

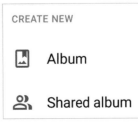

CREATE NEW

Album

Shared album

21

...cont'd

Hot tip

Tap on an item in Step 4 to follow a step-by-step process for creating the item, including selecting photos and any design features for the item.

Don't forget

For more details about editing photos with the Google Photos app, see pages 74-77.

4 Tap on the **For you** button on the bottom toolbar to access options for using your photos creatively, such as in photo books and collages

5 Tap on the **Sharing** button on the bottom toolbar to invite other people, via email, to have access to your photos

6 Select the person with whom you want to share your photos. They will be sent an email invitation, which they have to accept before they can view your photos

2 Photo-taking Basics

This chapter looks at how to ensure that you have a good basic foundation for taking photos on a mobile device, and being able to make the most of its controls.

Sharp and Effective Focusing

Good focusing is one of the essential elements of any photo: if a scene is not properly in focus then the resulting photo will be ruined regardless of how perfect the lighting is, or how well the shot is composed. Therefore, it is important to be confident when focusing shots on a smartphone camera.

One of the limitations of smartphone cameras is that they do not have a manual method of focusing by moving the camera lens. Instead, they use Auto Focus (AF) when focusing on a scene being viewed by the camera. This is a very effective way of focusing on a scene and, by default, the camera tries to get as much of the scene in sharp focus as possible. This usually results in a photo that looks sharply in focus wherever you look at it:

Hot tip

Once a photo has been taken, zoom in on it in a photo-editing app (or the Camera app if it has this facility) to ensure that it is sharply in focus. It is best to do this immediately after you have taken a photo, in case you need to take another one due to the first one not being sufficiently in focus.

Selecting areas of focus

Despite the effectiveness of Auto Focus, there may be occasions when you want to have the main focus of the photo at one specific point. If this happens, the smartphone camera will still try to get as much of the rest of the photo in focus as possible, but the area that you have selected will be the main focal point. This should guarantee that the main subject of the photo is in focus.

To specify a particular focal area in a photo:

1 Open the photo app and compose a scene

2 Press and hold on the screen on the area that you want to be the main focal area

3 A colored square appears over the focal area

4 Keep holding on the screen until the **AE/AF Lock** button appears at the top of the screen (AE is for the exposure of the photo – see pages 26-27. AF is for the Auto Focus). This indicates that the focal point has been set where you specified it, and will remain there once you remove your finger from the screen and move the camera

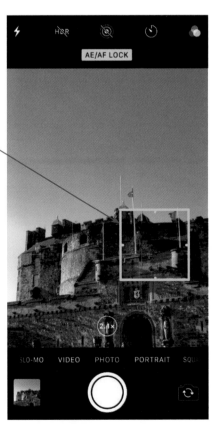

AE/AF LOCK

Don't forget

To ensure the best focus, use a method of supporting your smartphone camera to reduce the risk of your hand shaking slightly and causing an out-of-focus photo. This is known as camera shake. See page 33 for details about keeping your camera steady.

Selecting the Best Exposure

Exposure is another important element to consider before you tap on the Shutter button of a camera app to take a photo on a smartphone. This determines the amount of light that is captured when a photo is taken, and this subsequently creates dark and light areas within the photo: if the exposure has been measured correctly, all areas of the photo should be represented as correctly as possible – e.g. the dark areas are not too dark, and the light areas are not too bright. Smartphone cameras assess lighting conditions of a scene in order to create the correct overall exposure, using a matrix that takes a light reading throughout the scene.

However, there will be times when even this sophisticated method of assessing the amount of light in a scene produces results where either the dark areas are too dark or the light areas are too light, known as being burned out (in the example below, the sky area is too light).

If the exposure in a photo has produced an unsatisfactory result, it is possible to manually select an area of a scene where you want the exposure reading taken. For instance, if you want to ensure that the main subject is exposed correctly, take a reading from that point. The downside of this is that the rest of the photo will then use the same exposure reading, sometimes rendering it too dark or light, such as the sky area.

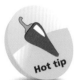

Hot tip

A lot of smartphone cameras have an HDR (High Dynamic Range) option. If this is turned on, the camera will automatically take several photos of a scene (usually three), each one with a different exposure. The camera will then combine these photos, to create a final photo that has the best exposures for each area of the scene.

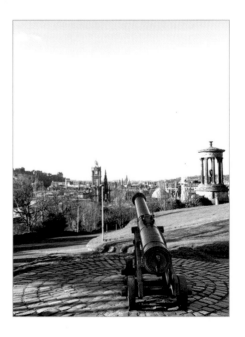

To select an exposure manually:

1 Open the photo app and compose a scene

2 Press and hold on the screen on the area that you want to be the main exposure area, in the same way as for locking the focal point

If required, drag the slider at the side of the colored square to alter the exposure for the selected area.

3 The **AE/AF Lock** button appears, to indicate that the exposure has been locked at the point within the colored square. This will provide the exposure for the final photo

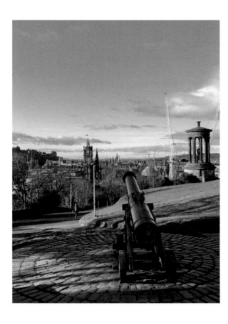

Take several shots of a scene, with the exposure selected for different areas of the scene. These can then be compared with a photo that is taken with the default auto exposure, as determined by the camera. This is known as bracketing.

27

Zooming Effectively

Being able to zoom in and out on a scene is an element of photography that can make significant differences to the composition of a photo. Smartphone cameras have a zoom function, so you can make subjects appear larger on the camera's screen. However, unlike traditional cameras, which use an optical zoom by changing the distance between the camera's internal lenses, digital zoom is the same as cropping a photo, or zooming in on it using a photo-editing app. Digital zoom works by increasing the size of the pixels on the screen, and produces an inferior quality than using optical zoom. It is therefore important that zooming is not overused on smartphone cameras: the greater the amount of zoom, the greater the reduction of photo quality (and the same effect can be achieved by cropping a non-zoomed photo). However, it can still be useful to use a certain degree of zoom, and there are two ways to do this:

Zooming by swiping

Scenes being viewed by a camera app can be zoomed in and out by swiping and pinching on the screen:

Hot tip

When zooming in on a scene, always leave a slightly larger border around the main subject than you think may be necessary. This can always be cropped out of the final photo, but if the border is too tight on the main subject, this cannot be rectified.

Don't forget

The amount of zoom applied by swiping or pinching is displayed on the screen.

1 Swipe outwards with thumb and forefinger to zoom in on a scene with the camera app

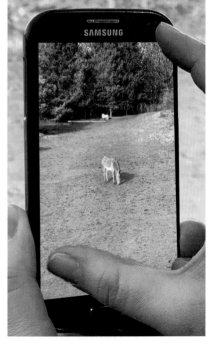

2 Pinch inwards with thumb and forefinger to zoom out on a scene

...cont'd

Using zoom buttons

Some smartphone cameras also have buttons that can change the amount of zoom by specific factors:

1 By default, the zoom button will be at 1x – i.e. no zoom applied. Take a photo with this setting

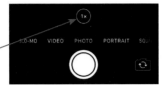

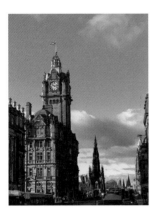

Don't forget

Zoom buttons only zoom in or out to a specific degree. To zoom in or out to a custom degree, use the technique on the previous page.

29

2 Tap on the zoom button to double the amount of zoom – i.e. 2x. Take a photo with this setting to capture the same photo but with a greater degree of zoom applied

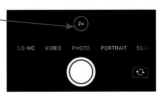

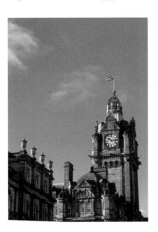

Making the Most of Light

Using light effectively is probably the most important element in producing eye-catching photos. There are some specific techniques that can be used in relation to light, and a few general points are:

- **Waiting for the best light**. Patience is a great asset when trying to capture great photos, and this is definitely the case when looking to use the best light. A few minutes, or even seconds, can mean the difference between a dull photo and one that is perfectly lit, due to the sun moving its position or emerging from behind a cloud.

- **Researching lighting conditions**. In order to try to utilize the best lighting conditions it is worthwhile doing a bit of research for your current location. This could involve assessing where the sun rises and sets, and finding out the times for when this happens. This will enable you to work out the best locations at certain times of the day, and plan your photographic exploits accordingly. Another important asset can be to check local weather forecasts to see the type of lighting conditions with which you may be faced.

- **Avoiding glare**. Natural sunlight is one of the best conditions for taking photos. However, there can be some issues when taking photos on bright, sunny days. The principal one is avoiding glare in a photo when taking shots directly into sunlight, or even side-on to it: the resulting photos can contain a flare of light because of looking into the sun. To overcome this, use your hand over the top of the camera, or use a book or a piece of card, to shade the camera and remove the glare (be careful that there is no shadow over the camera on the screen from the item shading it).

- **Using backlighting**. When taking photos of people outside, one of the best options is to have them with their backs to the sun. This will mean that they are not squinting due to having to look directly into the sun. However, a drawback of this is that their face may well be in shade, due to the sun being behind them. To overcome this, turn on the flash on your smartphone's camera, rather than leaving it on the default Auto setting, which will only fire the flash when it is deemed there is not enough light. Turning on the flash will have the effect of lighting the subject's face and balancing this with the sunlit background. This technique is known as backlighting.

In any lighting conditions, check each photo that you have taken before you leave your current location. If there are any issues with the light, these could be remedied at the time but not afterwards.

If you are taking photos into the sun, do not look directly at the sun through the camera app as this could damage your eyes.

Golden Hour

One of the most common lighting techniques involves taking photos as the sun rises or sets. This is known as the Golden Hour, and occurs approximately an hour after the sun rises and an hour before it sets. The great advantage of this is that at these times of day the light has a much richer texture to it, rather than the harsh sunlight effects that can be created by strong, overhead sunlight. As the name suggests, it can produce a rich, golden color that can result in outstanding photos.

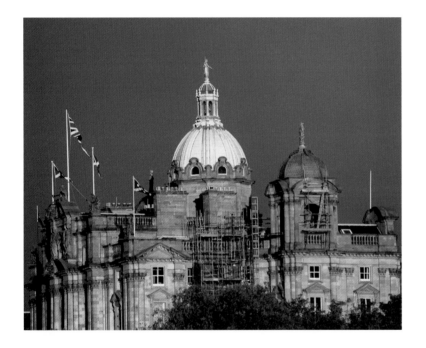

Hot tip

A lighting technique that is similar to the Golden Hour is known as the Blue Hour (or the Purple Hour). This occurs approximately half an hour before the sun rises in the morning and half an hour after it sets in the evening. Depending on the weather conditions (it is best if there are a few clouds around but not too many), this can create lighting conditions that have a blue or purple tinge to them. This can be ideal for capturing landscapes or cityscapes.

31

The morning and the evening Golden Hours produce slightly different effects: the morning sun has a soft golden effect while the evening sun tends to have a stronger orange glow with a bit more depth to it.

The other thing to be aware of about the Golden Hour is that it is short. This means that you will not have a lot of time to move from location to location. It is best to pick a single subject that you want to capture, and then concentrate on a few top-quality shots, rather than trying to include numerous subjects and not having time to get to them all.

Using Volume Buttons

Photos on smartphone camera apps are usually taken by tapping on the app's Shutter button. However, there may also be times when it is not so convenient to use the camera in this way: since the Shutter button in the Camera app is located at the middle, bottom of the screen, it is not always easily accessible if perhaps the smartphone is at an awkward angle, or you are stretching in order to get a better view of a subject. In instances like this it is possible to use the volume buttons at the side of the smartphone to take the photo:

Don't forget

Although tablets are not as convenient as smartphones for carrying around and using the camera, they can also use the volume buttons for taking photos.

1 Compose the photo as normal

2 Press the volume button (or the up or down volume buttons if the smartphone has more than one) to capture the photo

Steadying Your Camera

One of the most common causes of blurry photos is camera shake. This occurs when the camera is moving slightly when a photo is taken, caused by small movements in the hand of the person taking the photo. A lot of smartphone cameras have a technology known as image stabilization that is very effective at reducing camera shake, but there will be times when you want to keep your smartphone as still as possible when taking a photo (this is particularly applicable as it can sometimes be difficult to keep a smartphone steady when taking a photo with one hand). Some options for keeping your smartphone camera steady are:

- Use a small tripod to keep the smartphone steady at all times. Some tripods have legs that can be bent into different positions so that the smartphone can be kept steady and level on uneven surfaces.

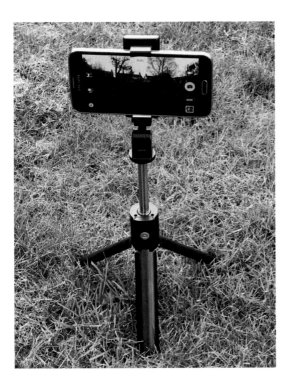

- Use an existing surface such as a bench, wall or a railing, to steady your arm and the smartphone.

- Carry a small beanbag with you to place the camera on when you require it to be steady.

Hot tip

One of the best uses for a small tripod is when you are using the self-timer for group shots. This way, the camera can be kept steady and you can include yourself in the group shot.

Hot tip

Some selfie sticks also double as tripods, and can also be operated with a remote control so that the self-timer is not required.

Maintaining Your Camera

Unlike traditional cameras, smartphone cameras generally do not have as many accessible moving parts. This means that they are less susceptible to damage through everyday irritants such as dirt and dust. However, there are still a few steps that can be followed to ensure that your smartphone's camera remains in the best condition:

- Keep the lens clean. If specks of dust or dirt are on the lens these could show up in photos. Use a soft, lint-free cloth (similar to those used to clean spectacles) to clean the lens, particularly at times when you are taking an important photo.

- Regularly inspect the lens for any physical damage, such as scratches. If the lens is scratched this will impact on all of your photos.

- Use a smartphone cover that has a raised edge to protect the camera: if the phone is dropped, the cover's edge should hopefully save the camera from any damage.

Hot tip

In addition to a smartphone cover that protects the back of the smartphone and the camera, use a screen protector in case the smartphone is dropped. This will minimize the chances of the screen being cracked.

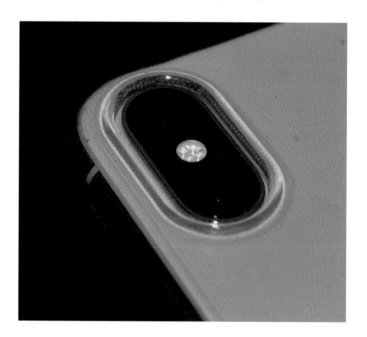

- Avoid extremes of heat or cold. These could affect the overall operation of the smartphone and therefore impact on the efficiency of the camera.

3 Composition and Light

Many of the rules for taking photos with a mobile device are the same as for any other type of camera. This chapter looks at using light and composition as effectively as possible, including techniques for positioning subjects for maximum effect.

Landscape and Portrait Modes

One of the most effective techniques in terms of composing photos with a smartphone camera is also one of the most simple: just rotating the smartphone 90 degrees can result in two dramatically different photos. This is known as taking photos in either landscape or portrait mode. Although the names suggest the type of subject for each mode, there is no reason why each orientation cannot take photos of all kinds of subjects.

Landscape mode is ideal for taking photos of its namesake and also photos of cityscapes:

Hot tip

For most scenes it is always worth taking separate photos, in landscape and portrait mode. This creates an instant variation of the scene being viewed.

Hot tip

To create artistic shots, the smartphone can also be held at an angle, between landscape and portrait mode. This can produce hit-and-miss results, but it is an experiment that is worth trying, particularly as you can view the results immediately.

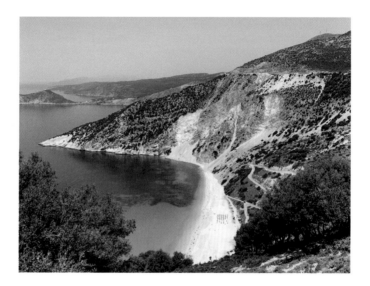

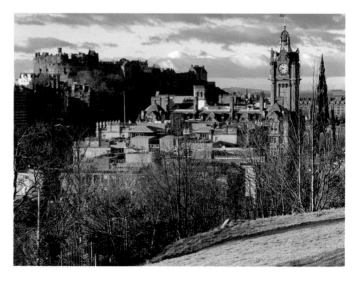

...cont'd

Portrait mode can be used for effective portraits of people and statues, and also items such as buildings and towers:

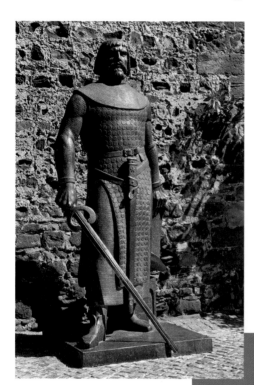

Hot tip

Photos taken in either landscape or portrait mode can also be cropped in a photo-editing app so that their original orientation is not always obvious – e.g. the final cropped photo may look square rather than rectangular in either landscape or portrait mode.

Applying the Rule of Thirds

Photography is not always an exact science: some of the best photos can be taken on the spur of the moment, or because someone has a good eye for a scene. However, some more formal techniques can also be used to try to ensure that you can confidently approach any scene. One of these techniques is known as the Rule of Thirds. This consists of looking at a scene as if it has been overlaid with a grid consisting of three lines horizontally and three lines vertically. This creates a grid with nine separate segments:

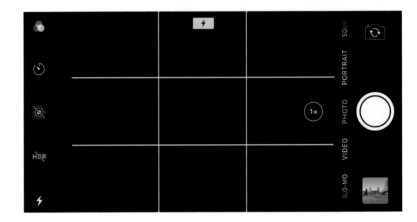

Hot tip

Some camera apps have an option for displaying a physical grid over a scene, rather than having to visualize it. This can be specified in the camera app's settings.

The advantage of the Rule of Thirds is that the grid can be used to position subjects within a composition, to give it a more balanced effect. Subjects can be positioned in any of the nine segments, on the lines, and also at the points where the grid lines intersect.

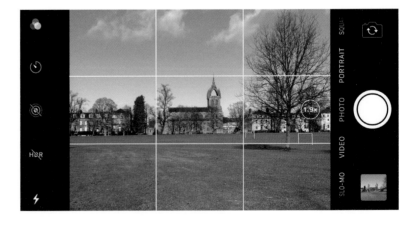

...cont'd

If you have a scene in front of you, it is worth experimenting by taking several photos, positioning each one in a different location, according to the Rule of Thirds. This can create significantly different end results.

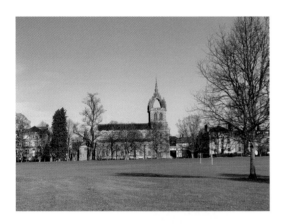

Don't forget

If you are using the Rule of Thirds this does not mean that you cannot position a subject in the middle of a photo: one of the segments of the Rule of Thirds grid is in the center after all.

Using Empty Space

Every part of a photo should be important, even if there is nothing immediately obvious in a section of the photo. Empty space in a photo, also known as negative space, is something that should be considered as a positive composition tool, rather than an issue to be ignored.

Empty space is an area that is not occupied by the main subject of a photo, and it is frequently an item such as the sky or an expanse of grass. It can be the foreground, the background, or both. Rather than being a redundant feature in a photo, empty space can be used to draw attention to the main subject, by emphasizing the contrast between the two: if there is a large amount of empty space, it can draw the eye to the main subject and make it more prominent.

Empty space can be used with objects, landscapes, landmarks, and people. It is always worth looking for empty space when composing a scene, and considering how it can be used to enhance a photo.

Hot tip

Paintings by famous painters can be a good source for seeing how empty space can be used to effectively emphasize a subject in a scene.

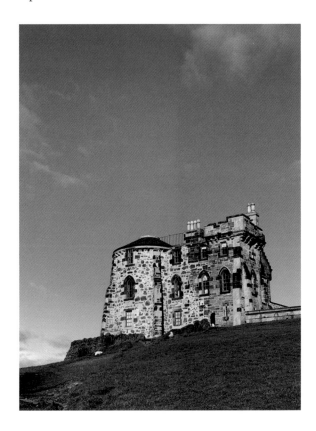

Getting in the Frame

Photos or pictures always look better in an appropriate and attractive frame, and the same is true for photos when they are taken. If the main subject can be framed in an interesting or artistic way, this can add considerable impact to the final photo. Framing options exist with natural or man-made elements:

- Use branches of trees to frame a landmark or a landscape scene.

Frames can also be added to photos in a lot of photo-editing apps. However, it is always a good option to try to find naturally occurring ones too.

- Use architectural elements to frame a specific item.

- Use an existing man-made frame or doorway to create a ready-made frame for a photo.

- Use someone's hands to frame a scene.

Identifying Symmetry

Being aware of your surroundings is a vital part of photography, regardless of the device you are using to capture the scene in front of you. It is important to think like a photographer and try to find interesting elements that can be incorporated into your shots. One area to be aware of is symmetry. This can be in the natural world or man-made, and it is an excellent option for eye-catching and artistic photos.

Finding symmetrical subjects to photograph can be a challenge, but if you set your mind to looking for symmetrical scenes you may be surprised how many you start seeing:

- Look for a combination of man-made features and natural components to create effective symmetry.

- Reflections can be a good way to create symmetrical photos, using either water or glass.

- Buildings contain numerous elements of symmetry, either close-up or from a distance.

Hot tip

Capturing a reflection on still water is an excellent option for creating a symmetrical photo.

Lines and Patterns

Looking for lines and patterns is an excellent way to create a sense of depth and give character to photos.

Lines

Using lines is an effective technique for creating a path through a photo, to lead the eye to a particular subject, or just to create an artistic effect.

- Use straight lines, such as roads, sidewalks, railway tracks, paths, or staircases, to draw the viewer's eye through a photo and create a sense of depth in the photo.

Lines can be used to create a "vanishing point" in a photo. This is where two parallel lines recede into the distance and appear to meet at a point in the distance.

43

- Use curved lines to create a more fluid path through a scene or setting.

...cont'd

Patterns

Patterns occur all around us, and they are ideal for photography. They can give a real sense of character to a building or as a detail in nature.

When taking photos of patterns, try to get as close as possible to capture the greatest amount of detail. For some subjects, it is effective to take wide-angle shots of the whole thing and then some close-ups of patterns, to capture the overall character of the subject.

Patterns do not have to be symmetrical, and the important thing to remember is that they can occur almost anywhere. They are also an excellent way to show the texture and color of objects.

Hot tip

In addition to looking for naturally occurring patterns, it is also possible to create your own and incorporate them into a scene.

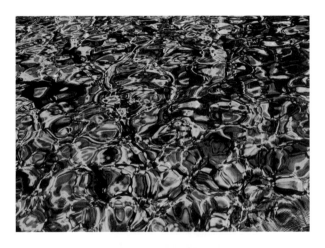

Reflections

We are surrounded by reflective surfaces and if these are embraced, they will offer a range of photographic opportunities. Some areas to look for reflections include:

- Reflections in water. Water is an ideal medium for reflecting landscapes, objects or animals. Still water, such as a lake, is the best for creating a clear reflection, and rippling water is also excellent for more artistic effects.

45

When using reflections you may find yourself reflected in the photo while you are taking it. This can be an effective artistic technique, but make sure that it is done intentionally.

- Use sunglasses to capture the reflection of an object or a person in the lens.

- Use car wing mirrors to capture an interesting foreground and background.

- Use glass on a building or a vehicle to create an eye-catching effect, particularly if you can also include the subject in the photo, as well as the reflection.

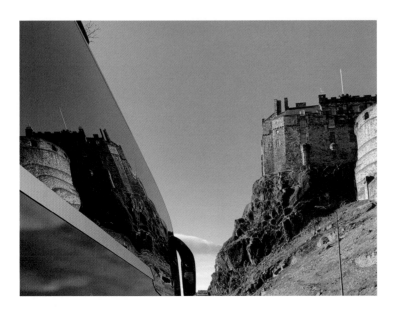

Changing Your Position

When you are taking a photo, you want to be as still as possible. However, when composing scenes it is beneficial to change the position from where you are taking photos, to create a different perspective for the shot. If you move your position you can create dramatically different results if you are taking several photos of the same subject. Even a small movement can have a dramatic effect on the final photo:

Hot tip

Another option for changing position is to try to find a higher viewpoint, to look down on the subject.

- Start by taking a standard, straight-on shot of your subject, from a reasonably close distance.

Beware

Never put yourself in danger when trying to find a new position from which to take a photo. Do not stand too close to locations such as a cliff top or the edges of buildings. Some people put themselves in danger by trying to take selfies in outrageous locations, but this should be avoided at all costs.

- Move away from the subject, and get as low as possible, to change the scene by including much more of the subject and a larger foreground in the photo.

Finding the Best Time

As with many aspects of life, timing is important in photography, for ensuring the best photos. This involves the time of day at which you are capturing photos, since this can have a significant impact on the type of lighting that is available, in terms of the location of the sun.

Another issue with timing covers the physical process of capturing photos. Frequently in photographic situations it is all too easy to rush the photo-capturing process. This can be exaggerated if you are faced with an especially enticing scene: the tendency is to rattle off a lot of photos quickly in order not to miss the shot. Before you do this, it is a good idea to create a checklist for capturing the best photos possible. It will only take a few moments, and will bring significant rewards later:

- Make sure that the lens of the smartphone camera is clean (use a lint-free cloth or a spectacles cloth).

- Check your smartphone camera settings. If you change the setting for a certain shot, these settings will usually be retained until you change them again.

- Check your smartphone's battery level before you embark on any photographic activity: you do not want the battery to run out just when you have composed a perfect scene for a photo. If you are worried that your smartphone battery may run out before you have finished taking photos, take a mobile charger with you so that it can be used in case of an emergency.

- Ensure you have the best composition.

- Keep the smartphone steady. This can be done with a smartphone tripod, a beanbag, or by steadying yourself against a solid object.

- Focus accurately and then capture the photo. Quality over quantity wins every time.

Sometimes just a few minutes can make all the difference to a photo. Waiting for a cloud to move so that the sun comes out to illuminate your subject can turn an average photo into a standout one, even if you have to stand and wait for a few minutes. If you are aware of your surroundings and the prevailing weather conditions, you can time your photo taking accordingly.

Creating Silhouettes

Silhouettes can be one of the most evocative and dramatic forms of photograph. They can be created from landscapes, buildings, and people. In fact, almost any object can be turned into a silhouette in the correct lighting conditions.

The secret to creating a silhouette is in having a subject against a bright, backlit background. This will ensure that there is more light falling behind the subject than on the front of it. This can be done at night if there is a light source behind the subject, or during the day by shooting directly into the sun. To create a silhouette in this way, press and hold on the light area of the photo, by locking the exposure as shown on page 27, and compose the subject accordingly. This will allow enough light to enter the camera to expose the background correctly, but there will not be enough for the foreground subject. This will result in the main subject being under-exposed – i.e. too dark. Since the background is a lot lighter than the subject, the under-exposure should be enough to create a black silhouette effect. If not, try locking the exposure on an even lighter area.

Beware

If you are creating a silhouette by facing the sun, do not look at the sun, either directly or on your smartphone.

Beware

If you do not specify the point of exposure as the bright background, the smartphone camera will try to create an even exposure in the photo, resulting in the main subject being slightly under-exposed, as opposed to completely under-exposed, as required for a silhouette.

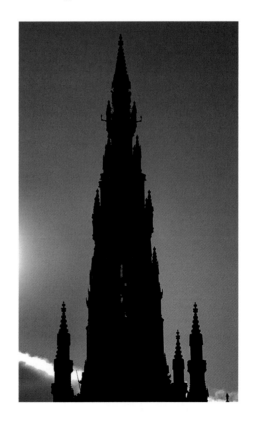

4 People and Portraits

Photos of people remain one of the most popular areas of photography. This chapter looks at using selfie sticks for capturing photos of people, and also ways to get the best out of your people photos.

Perfecting Selfies

Selfies are very much a phenomenon of the smartphone camera age. These are self-portraits that are taken using the front-facing camera on a smartphone – i.e. the one that you look at when you are looking at the screen of the smartphone. Selfies are frequently uploaded to social media sites, directly from the smartphone. Although selfies are very quick to take, there are some issues to consider:

- **Treat them for what they are**. Selfies are rarely going to reach the pinnacle of photographic excellence, and they should be treated as a bit of fun that can be shared with family and friends. If you want to get a more professional photo of yourself, ask someone else to take it or use the self-timer on the smartphone's camera.

- **Selfie sticks**. Few things divide the photographic world as much as selfie sticks. These are devices that the smartphone is attached to and then selfies can be taken from a greater distance away from the subject, operated by a button on the selfie stick. To some they are the ultimate mobile accessory; to others an intrusive contraption that has become an eyesore. But love them or hate them, it is undeniable that they can produce more effective selfies, because of the extra distance away from the subject and the greater amount of background that can be included in the photo. Selfie sticks can be operated via a cable that attaches to the smartphone (see next page) or via a Bluetooth connection (see page 52).

- **Keeping safe**. There have been instances from around the world where people have come to harm by taking selfies in dangerous locations, such as near the edge of cliffs. This is reckless in the extreme, and you should never put yourself or others in danger when trying to take a selfie. If you are near a drop of any kind, always make sure that you know where your feet are in relation to the edge. Do not feel tempted to move one way or another without first looking exactly where you are going to place your feet. Also, do not rely on someone else's judgment if they are telling you where to move – always look first, regardless of what someone is saying.

- **Use on social media**. It is preferable to use a limited number of good-quality selfies on social media sites, rather than flooding them with dozens, or hundreds, of average ones.

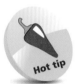

Hot tip

Selfie sticks can also be effective for taking group photos.

Cable Selfie Sticks

Cable selfie sticks are inexpensive and easy to set up and use. They consist of four main elements:

Top clamp, for holding the smartphone

Connection cable

Telescopic tube for expanding the selfie stick

Shutter button, located on the handle of the selfie stick

Selfie sticks can be expanded by pulling upwards on the telescopic tube.

To use a cable selfie stick:

1 Insert the smartphone into the top clamp and connect the cable to the smartphone's microphone jack

Some smartphones, particularly iPhones, do not have a headphone jack. If this is the case, a Bluetooth selfie stick can be used instead – see page 52 for details.

2 Open the smartphone's camera and press the Shutter button on the handle of the selfie stick to take the photo

Bluetooth Selfie Sticks

Bluetooth selfie sticks are slightly more sophisticated than their cable counterparts, but they perform the same task. However, the connection between the smartphone and the selfie stick is a wireless Bluetooth one, rather than a physical one with a cable. To use a Bluetooth selfie stick:

Hot tip

Some selfie sticks double up as tripods, which can be used to keep the smartphone steady when taking a photo, or when using the self-timer.

Hot tip

Some selfie sticks use a detachable remote control for taking photos. It can be used in position on the selfie stick as in Step 5, or it can be removed and used away from the smartphone, and does not have to be attached to the selfie stick.

1 Attach the smartphone to the selfie stick's top clamp (this will be the same as for a cable selfie stick, except that there is no cable)

2 Tap on the **Bluetooth** option in your smartphone's settings

3 Turn **On** the **Bluetooth** option and tap on the selfie stick name when it appears

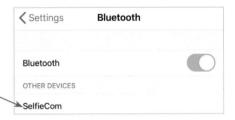

4 Tap on the **Pair** button to link the smartphone and the Bluetooth selfie stick, so that they can communicate

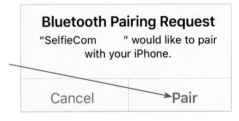

5 Open the smartphone's Camera app and press the Shutter button on the selfie stick to take a photo

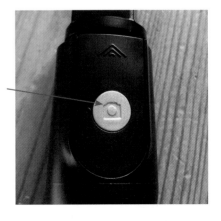

Using Selfie Sticks

One area in which selfie sticks can be more effective than just holding your smartphone camera in your hand is when taking a selfie with something in the background. This enables you to include more of the background than just taking a standard selfie:

1 With a standard selfie it can be hard to capture a lot of the background

2 Use a selfie stick to increase the camera's angle and include more of the background or landmark behind you

Be careful when taking group selfies, particularly in crowded areas, not to impede or inconvenience any other people.

Another option for using selfie sticks is for group selfies. To do this, assemble the group and position the selfie stick so that the whole group is in the shot.

Mastering Group Shots

Organizing a group of people for a photo can sometimes be a fraught task: trying to get them together and then ensuring that they have the best expressions. In situations like this you have to think of yourself as a bit of a film director: plan the shot first and then take control of the group and, if necessary, take a bit of time to organize them correctly.

- Try to avoid a shot with everyone standing with their arms at their sides looking directly at the camera. If possible, arrange people to be doing something eye-catching. Also, pay some attention to what they are wearing so this can be a positive part of the photo too. Try to co-ordinate colors, or arrange them in specific patterns – e.g. keep certain colors together and arrange people in order of brightness of clothing.

- Ask people to stand side-on, or at an angle, so that they are not facing straight-on to the camera.

- Perform a pre-arranged action for the group – e.g. on the count of three, everyone throws their arms up in the air, at which point you take the photo.

- Try to position the group either above or below you. Staircases are good for this: either arrange the group going up a staircase and capture the photo from the bottom, or go to the top of the staircase and take the photo looking down on the group below. Although these are now slightly clichéd shots, they are nonetheless still effective.

- At an event such as a wedding, one of the quickest and easiest ways of capturing large group shots is to just copy the official photographer (if there is one). They will create all of the poses and you can then stand beside or behind them and capture the same photos (try to stand just behind, since if you are at the side, the group will be looking at the photographer rather than you).

- Use the camera app's self-timer to include yourself in a group shot. This can be activated from within the camera app and be set for differing amounts of time before the photo is taken: usually 3-, 5- or 10-second intervals (see next page for details).

Hot tip

Another useful technique for taking group shots is to ask everyone in the group to close their eyes and look down for a few seconds. Just before you take the photo, tell everyone to open their eyes and look up. If this is timed properly it can result in more natural expressions on the faces of the members of the group.

Self-timer for Group Shots

When you are taking photos with your smartphone it is logical that you are not always in the photo (unless you are taking a selfie). However, when taking group shots it is possible to include yourself in the photo by using the camera app's self-timer. This enables you to set a timer, of varying duration, so that you have time to position yourself in the photo.

If you are using a self-timer, try to position yourself where you want to be in the photo before it is taken (if possible, get someone else to look at the composition of the photo from where it is going to be taken, to ensure you are in the best position). To use a self-timer for taking group photos:

Hot tip

The self-timer can also be used to include yourself in front of a notable landmark. If you do this, do not leave your camera unattended too far away from where you are, in case someone steals it.

1 Position the smartphone so that it is facing the group and supported in some way – e.g. with a smartphone tripod

2 Open the camera app and tap on this button to access the self-timer

3 Select one of the timer durations

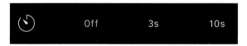

Off 3s 10s

4 The selected duration is shown next to the self-timer icon

10s

5 Tap on the Shutter button to take the photo. A countdown appears on the screen, and the photo is taken at the end of this

Don't forget

Patience is probably one of the greatest attributes when taking photos of children. Do not expect to take the perfect photo first time, and proceed at their pace rather than your own.

Hot tip

Adding props can be a useful option when taking photos of children. Give them a puzzle to do, such as a Rubik's cube or a Sudoku puzzle. Or, take a photo while they are reading a book or performing some form of physical activity, such as throwing and catching a ball.

Children and Animals

"Never work with children or animals", is a famous adage in the movie industry, and the same could perhaps be applied to the world of photography.

Children

There are probably more photos of children taken on smartphone cameras than any other subject. However, there are several considerations when trying to get the perfect shots of children:

- One of the main issues when capturing photos of children is that they tend to perform a passable impression of perpetual motion. They are rarely still for very long so it can be a challenge to try to capture effective photos of them. Patience is definitely a virtue when it comes to taking photos of children.

- Portraits of children are familiar photographic subjects, and there is absolutely nothing wrong with a standard, face-on portrait.

- In addition to portraits, try to capture photos that offer something slightly different: put the child in an unusual or picturesque location or include additional elements in the photo such as flowers or family pets.

- Capturing photos of children involved in an activity is an excellent option too. This is because their attention is diverted and there is also the activity itself to help make the photo more interesting.

- If you are taking photos in public areas that could involve other people's children, try to ask permission from their parents/guardians: people can become understandably anxious if they think that there is a stranger taking photos around their children.

- Be careful if you are sharing photos of your children on social media. Make sure that there are no other children in the shots (unless you have gained permission from their parents/guardians), and remember that once photos are on the web it is likely that they will stay there indefinitely: even if you delete them, their digital footprint can remain.

Animals

When capturing photos of animals there are two main ways to go about it: either in the wild or in some form of confinement such as zoos, agricultural shows or wildlife parks. In the wild, it is a lot harder to get good pictures, and you will need a good zoom option on your smartphone camera and a lot of patience. Rather than chasing after animals, the best way to operate in the wild is to select a spot (and preferably use some form of hide or shelter) and then let the animals come to you. Depending on the type of wildlife this could take several hours but it is worth remembering that most stunning photos of wildlife have probably taken days, or even weeks, to capture. It is rarely just a case of turning up, snapping away for a few minutes and then going home.

For animals in some form of captivity, the photographer's job is made easier, if only because you know where the animals are going to be. When you are capturing photos in these types of conditions it is also worth being patient so that you get the best possible shots. Try to avoid too much foreground or background detail that reveals your location, and try to get as much of an animal's character as possible.

Beware

Never do anything that may frighten or harm animals when you are photographing them.

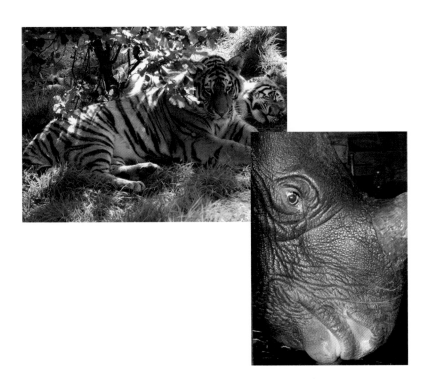

Capturing Candid Moments

A good photographic portrait may adorn your wall or mantelpiece for many years, and it is one of the most common ways to capture photos of people. But unposed, or candid, shots can be just as appealing and they offer a different type of insight into the character of the subject.

Candid shots can be captured on the spur of the moment, when an appropriate opportunity presents itself. However, there are also some steps that can be taken when capturing candid shots of people around you:

- The best way to capture candid shots is to ensure that the subject is unaware of your presence with a camera. (This is where a smartphone camera can be useful, because we are all increasingly accepting that most people will have one of them in their possession.)

- If there are other people around, you can try blending in with them, or place yourself behind an object such as a car or a pillar (but make sure it does not look as though you are spying on the subject).

- Another, perhaps better, option is to use the zoom function on the smartphone's camera. This will enable you to stand far enough away from the subject so that they do not realize you are trying to photograph them. Using the zoom will also result in being able to fill the frame without having to be too close to your subject. This is an excellent way to get candid shots that are also full of character.

- Patience is the key when capturing candid shots: sometimes you will have to wait several minutes until you get the right photo (since you cannot tell the subject what you want them to do). In some ways, it is similar to capturing photos of wildlife, in that you have to make yourself inconspicuous and then be prepared to wait.

- Convert portraits into black and white to give an extra artistic touch to your subjects. If the original photo was taken in color, make a duplicate and use the copy to convert it to black and white using a photo-editing app (see page 158 for details about converting photos to black and white).

Beware

Do not try to take candid portraits or any other kind of photos of sensitive subjects, such as military personnel, particularly if they are near to military installations or airfields.

58

5 Buildings and Landscapes

This chapter looks at photographic opportunities that are all around us: buildings and landscapes. It looks at areas of composition to make these types of photos stand out from the crowd.

Emphasizing Size

The size of some buildings is integral to their existence: some towers are deliberately built to try to be the tallest in the world, or the imposing nature of a building is testament to the power of their patron or designer.

When taking photos of buildings, a straight-on shot does not always do them justice in terms of their size. Different techniques can be used to show the imposing nature of a building, or represent it as a small part of its surrounding area. Either way, it is a useful option for revealing some of the character of a building.

● The size of a building can be emphasized by capturing a photo from directly below it. This creates a sense of perspective, and can be used to exaggerate the size of a structure. This can involve getting as low to the ground as possible, and even lying down on the ground to be able to point the smartphone camera upwards while still being able to see what is on the screen. If you do this, make sure that it is safe to do so, without impeding other people or traffic.

Hot tip

Another option for emphasizing the size of a building is to make it look relatively small compared to its surroundings, even if it is a large structure. The best way to do this is to use a wide shot to capture as much of the surrounding area as possible. If there are other objects in the picture that can be used to contrast with the size of the building then so much the better.

Looking at Angles

When taking photos of buildings, they should not be thought of as two-dimensional objects, which is how they can appear if the photo is composed as a straight-on shot. While this can create highly effective and instantly recognizable photos, it would be wrong to concentrate on this type of photo exclusively. Buildings are frequently a fascinating combination of curves and angles that can create a much broader context for photos.

All buildings have angles and these are a rich source of photographic opportunities. Angles can be used to emphasize the size of a building, giving it a completely different character from that seen in a straight-on shot from further away.

Don't forget

If possible, walk all the way around a building before you start taking photos of it. This will enable you to find the best angles from which to take your photos (and also assess different lighting conditions around the building).

For this it is important to find the right spot from which to capture the angles of the building or structure. If photos are taken from a variety of different angles this gives you a chance to explore its different characteristics and style.

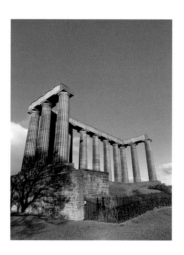

Using Foreground Elements

The composition of any photo should not be thought of as a single layer. In reality there are three main elements to any photo: the foreground, the main subject and the background. The main subject is usually the element that is given the most attention, but the other two should not be ignored, particularly the foreground.

The foreground can be an important factor in photos and should be treated as a composition feature in its own right: it can be especially effective in photos of buildings and landscapes. It creates an extra element of interest and can enhance the main subject of a photo and the overall composition. It can take a bit more effort to include an effective foreground in a photo, but it is something that will pay great dividends.

Foreground objects can include natural elements such as trees or flowers and they can also consist of man-made items:

Getting the Iconic Shot

There are many buildings and landmarks around the world that are widely recognizable and it is completely understandable that photographers want to capture iconic shots of these subjects. This does not mean that you cannot also try to take some more unusual shots of the same subject, but it can be satisfying to know that you have an iconic shot of a famous building or landmark. Some points to consider when doing this are:

- Make sure that you get the right lighting conditions. This may be the Golden Hour (see page 31), when the sun is just rising or setting, and it is usually preferable to have the sun behind you so that it illuminates the subject. If possible, research the subject before you take a photo of it and check what the light looks like at different times of the day.

- Once you have checked the lighting conditions, wait until the light is exactly as you want it.

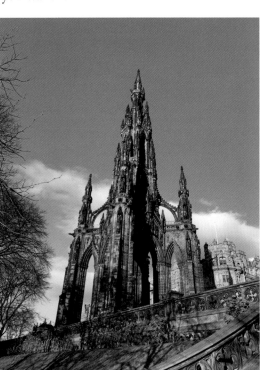

- If there is a large crowd of people around the subject, wait until as many as possible have dispersed, so that you can concentrate on the subject on its own.

- Use a postcard of the subject to work out the best location to stand when capturing it.

- Take numerous shots to make sure that you get the perfect end result.

Don't forget

You may never return to a certain location or landmark, so it is worth taking as much time as possible to ensure that you have the best possible photos.

Don't Forget the Details

One of the most interesting aspects of buildings, particularly when taking photos of them, is the level of detail that can be seen within them. Most buildings are made up of different elements that are combined to create the whole structure. Within these elements there can also be a multitude of smaller elements, some that serve a particular purpose, such as a door handle, and some that are solely decorative.

When taking photos of buildings it can be productive to concentrate on the details as well as the overall appearance of a building, as there is a wealth of photographic material to be found.

Building details can cover a range of elements: windows, door handles, artwork, tiles, and stone carvings.

Hot tip

A lot of building details cannot be seen from a distance, so get as close as possible to examine some of the finer points of a building.

A useful way to capture detail in a building is to start at a distance from where you can capture the whole building and then work your way closer and closer to capture the details. This can be used as a series of photos to show different aspects of the same structure, and each of the photos should be able to stand up in its own right as well.

Hot tip

Always look up to the top of buildings, as a lot of objects of interest can appear here.

Telling a Photo Story

Some photographic locations offer the chance for one single, stunning photo. However, in most cases, there are numerous opportunities for capturing a variety of photos. Even if you cannot immediately see the chance for different photos, it is always worthwhile looking around a location to see if you can capture a range of shots. Once you have perfected this, you should be able to create a photo story in almost any situation. This is a collection of photos that together give a sense of the character of a location.

Wherever you are with your smartphone camera, try to think of the different types of shots that are available, with a view to creating a photo story for the whole event. For instance, if you are on holiday on the beach:

- Take some shots of your family building sand castles or playing in the water.

- Have a look at the sea and the waves, and try to capture some artistic shots of the water and any waves that are visible.

- Take a walk along the beach and look in rock pools for any signs of life. Also, take some texture shots of the rocks and plants themselves.

- Take some photos of any people who are working on the beach, selling souvenirs or refreshments.

- Take some shots of any activities that are on offer, such as paragliding or jet skiing. Try to make them as large as possible by using the zoom on the camera.

- Finally, at the end of the day capture some social shots of people leaving the beach, to contrast with the action and enjoyment of earlier in the day. Look at the obvious, and then try to enhance this with as many different types of shots as possible.

If you try to create a photo story rather than just taking random photos, the end result will create a much more interesting collection and result in something that you are happy to show family and friends, either as a printed sequence or displayed on a social media site.

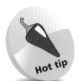

Hot tip

If you are going to a particular event, such as a sporting event, plan the aspects of the photo story before you go, and make notes of the types of photos that you want to capture. This will give you specific tasks when you are at the event, rather than just taking random shots.

Beware

Do not take photos of other people's children without asking for permission first.

Being Original

While there are certain techniques and rules that can be followed to create effective photos, it is also an intuitive medium: originality and spontaneity should not be forgotten when you are using your smartphone camera. Don't be afraid to experiment with different techniques to create original results. Some areas to consider include:

- **Humor**. This is very subjective in any walk of life, and this includes photography. The one guide to follow is, if you think something is humorous, then take a photo of it (as long as it is not offensive in any way). This can include incongruous items that do not usually fit together; people in unusual situations; or staged photos such as people seeming to be leaning against the Tower of Pisa or showing the height of the Eiffel Tower between their fingers. If you are staging a photo for humorous effect, make sure that no-one is put in a dangerous position – no photo is worth risking health.

- **Camera angle**. Instead of using a horizontal or vertical view, try using the camera at a different angle, such as 45 degrees. This may not always produce effective results, but occasionally a photo may be taken that is original and worth keeping.

- **Camera movement**. Usually, good photography relies on the camera being kept as still as possible. However, for something different try moving yourself or the smartphone camera while taking a photo. This can include turning around when taking a photo or, if you are brave and careful, turn on the self-timer and throw the smartphone into the air just as the photo is due to be taken. If you do this, make sure that there is a soft landing for the smartphone, just in case you do not catch it.

- **Breaking the rules**. Experiment by changing the normal point of focus or exposure (see pages 24-27) by using the focus or exposure lock feature on an area that is different from the one you would normally select.

- **Creating your own style**. This could include taking photos of specific subjects or including certain items in your photos on a regular basis. You can also experiment with creating your own style when editing photos in a photo-editing app.

Beware

Do not expect everyone to share your sense of humor, and do not be offended if they do not find your photos as amusing as you do.

Capturing Panoramas

When faced with an impressive landscape or cityscape scene, one good photographic option is to take a panorama. This is a photo where two or more photos are combined to provide a wider final photo that is captured in a single shot. Some smartphone cameras have a function to create panoramas automatically using the Camera app. To do this:

Beware

The more photos used in a panorama, the more the final photo will appear distorted due to having to fit different views into the final panoramic photo.

Hot tip

There are specific photo-editing apps for stitching photos together for a variety of uses, including panoramas. Type **photo stitching** into the Search box of the relevant app store for your smartphone.

1 Open the Camera app and tap on the **Pano** option

2 Tap on the **Shutter** button

3 Move the smartphone camera slowly along the whole panoramic subject

4 Tap on the **Shutter** button again to complete the panorama

Move iPhone continuously when taking a Panorama.

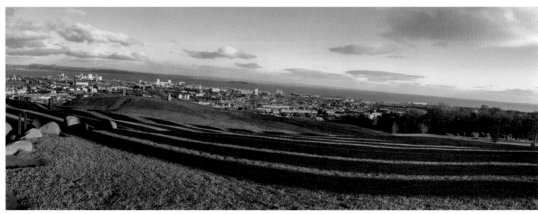

6 Using Editing Apps

Smartphones and tablets are ideal for editing and displaying photos once they have been captured on the device. This means that all of your photographic needs can be accommodated on a single device. This chapter shows the type of editing that can be undertaken with a photo-editing app, and also looks at a range of these apps, covering different areas of photo editing, from the in-depth to the fun.

About Editing Apps

Smartphones and tablets are much more versatile than just being able to take photos with a camera: editing apps on the devices can be used to edit and enhance photos so that you can present them in as perfect a state as possible.

Smartphones and tablets have their own proprietary editing apps (both called Photos on Apple and Android devices), and a large range can also be downloaded from the device's related app store. Editing apps can be used to manage and display photos, and they can also perform an array of editing techniques, including:

Don't forget

Photo-editing apps should have a full list of their features when you view their details within your device's app store, as in Step 4 on the next page.

- Enhancing the overall color of a photo, in one tap.

- Enabling sophisticated tools to manually improve all aspects of the color in a photo.

- Adding filters to transform a photo.

- Cropping a photo so that the main subject stands out.

- Selecting areas so that editing effects can be applied to the selection, rather than the whole photo.

- Removing blemishes such as wrinkles and spots.

- Fixing red eye, when someone's eyes appear red as a result of the flash reflecting in them. This can be done for people and also for pets.

Hot tip

When it is first opened, a photo-editing app will ask for permission to access the photos in the library on your smartphone or tablet. This should be agreed to, so that you can use the app to edit the photos already on your device.

- Adding sharpening to a photo, to make it appear more sharply in focus.

- Adding text to photos. This can be customized in a variety of ways in terms of fonts and style.

- Applying artistic special effects, such as converting a photo into a watercolor painting.

- Applying fun special effects, such as transforming someone's face into a cartoon character.

- Adding lighting effects to a photo, such as lens flare, a star burst, or light streaks.

- Adding stickers and other graphical elements.

Obtaining Editing Apps

Both Apple and Android mobile devices have their own default photo-editing apps, both called Photos. However, there is a wide range of third-party photo-editing apps that can be downloaded from your device's app store. These can be used for general editing tasks, and some apps perform more specific tasks, such as creating photo collages or applying entertaining special effects. To find and download third-party photo-editing apps:

1 Access either the Apple App Store or the Google Play Store (depending on your device)

2 Type **photo editing** in the Search box

Hot tip

To find photo-editing apps for specific tasks, enter search phrases such as **photo collages** or **fun photo effects** into the app store Search box.

3 The related apps are displayed

4 Tap on an app to view more information about it and download it, if required

71

Apple's Photos App

As shown in Chapter 1, Apple's iPhone and iPad use the built-in Photos app for managing photos that have been captured with the device's camera, or obtained through other methods such as downloading from an email or creating a screenshot. In addition to managing and displaying photos, the Photos app can also be used to edit them. To do this:

1 Tap on the **Photos** app to access your photos

2 Tap on the **Photos** button on the bottom toolbar to view all of the photos, and tap on one to open it at full size

3 Tap on the **Edit** button

4 The main editing categories are accessed from these buttons on the bottom toolbar

5 Tap on this button on the bottom toolbar to access the color-editing options

6 Tap on one of the color-editing options. These include **Exposure**, **Brilliance**, **Highlights**, **Shadows**, **Contrast**, **Brightness**, **Black Point**, **Saturation**, **Vibrance**, **Warmth**, and **Tint**

7 For each option, drag here to apply the required amount of the selected effect

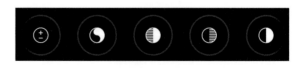

Hot tip

The first color-editing option on the toolbar in Step 6 (which appears to the left of the icons shown) is the **Auto** function. Tap on this to have a range of color-editing effects applied automatically.

8 Tap on this button on the bottom toolbar to access the filter effects options

9 Swipe here to view the filter effects and tap on one to apply it to the current photo

The middle and right-hand buttons in Step 10 can be used to rotate an image vertically or horizontally respectively. The first button is used to straighten an image by incremental amounts. Drag on the scale below the button to specify the amount of straightening to be applied.

10 Tap on this button on the bottom toolbar to access the straighten and rotation options

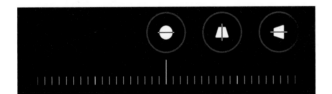

11 The same section as in Step 10 can also be used to crop the image, by dragging on the resizing handles in each corner

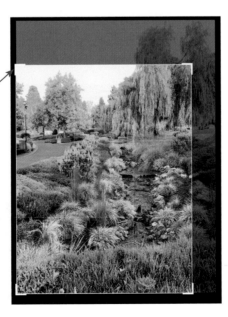

If you have edited a photo, the **Revert** option will be available if you go back to the Edit section again. Tap on this button to go back to the version of the photo before the previous editing session was completed.

Revert

Google's Photos App

Android smartphones can use the Google Photos app for managing and editing photos on the device. To do this:

1 Tap on the **Photos** app to access your photos

2 Tap on the **Photos** button on the bottom toolbar to view all of the photos, and tap on one to open it at full size

3 Tap on the **Edit** button

4 The main editing categories are accessed from these buttons on the bottom toolbar

5 Tap on this button on the bottom toolbar to access the filter options

6 Swipe on the filters' thumbnails to view the options

If the Google Photos app is not pre-installed on an Android device it can be downloaded, for free, from the Google Play Store.

The Google Photos app can also be used on Apple devices (i.e. the iPhone and the iPad), and can be downloaded from the App Store.

7 Tap on different filter options to see how they affect the photo. Each filter is applied to the original photo

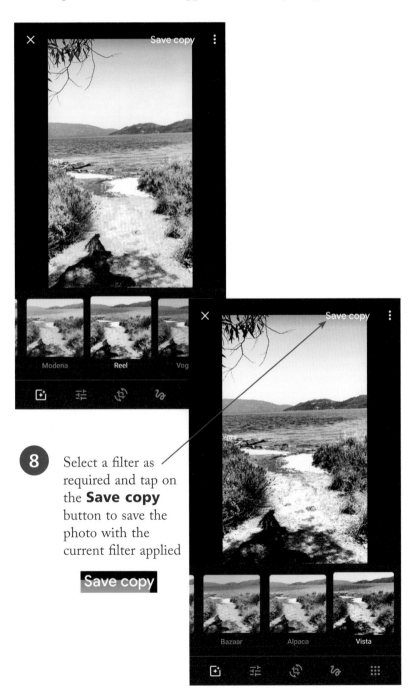

Hot tip

Creating numerous versions of the same photo, with a variety of different filters, is a good way to display a creative sequence with a single photo.

8 Select a filter as required and tap on the **Save copy** button to save the photo with the current filter applied

...cont'd

9 Tap on this button on the bottom toolbar to access the color-editing options

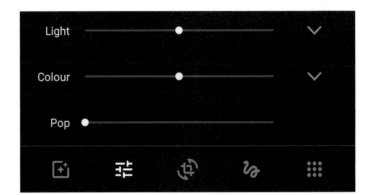

10 Tap here to access additional options for each item. Drag the slider to apply the effect for each item

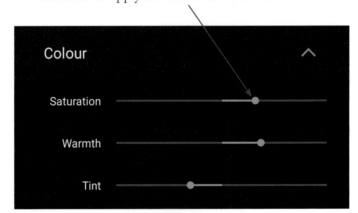

Don't forget

The options in Step 11 also include a function for cropping the photo, which is visible above the panel in Step 11. The photo can be cropped by dragging the resizing handles in each corner.

11 Tap on this button on the bottom toolbar to access options for rotating the photo

...cont'd

12 Tap on this button on the bottom toolbar to access options for adding drawings and text to a photo. Select the drawing tools to create a freehand drawing on the photo

Tap on the colored circles above the drawing and text tools to select that color for a drawing or text.

13 Tap on this button to add text to a photo

14 Tap on the text box on the photo to add text at this point

15 Add the text to the photo

After any editing changes, tap on the **Save copy** button as in Step 8 on page 75, to create a copy of the edited photo, and keep the original intact.

Save copy

77

Photoshop Express

Since the early days of photo editing, Adobe Photoshop has been synonymous with editing photos on computers and digital devices. The full version of Photoshop is a very powerful photo editor that is used by professionals such as graphic designers. The consumer version, Photoshop Elements, can be used to edit photos and produce a range of creative effects. Now, Photoshop is available on mobile devices, in the form of Photoshop Express, also known as PS Express. This is an app that can be used on smartphones and tablets so that you can use the power of Photoshop as soon as you have captured a photo on your mobile device. To use PS Express:

Photoshop Express is free to download from the Apple App Store or the Google Play Store, but some features can only be used in the Photoshop Express Premium version, which requires a monthly subscription fee. There is a three-day free trial for the Premium version. Features that require the Premium version are denoted by this icon.

1 Tap on this button to open PS Express

2 Tap on the **Edit** tab to access the photo library

3 Tap on a photo to view it at full size. The editing categories are available on the bottom toolbar

4 Tap on this button on the bottom toolbar to access themes that can be applied to the photo. Swipe along here to view the different themes, and tap on one to apply it

5 Tap on this button on the bottom toolbar to access filters that can applied to the photo

6 Tap on one of the filters to apply it to the photo

Hot tip

Tap on this button when the Photoshop Express app is first opened to access the Camera function, which can be used to take photos with filters and effects applied to them.

7 Tap on this button on the bottom toolbar to access effects that can be added

79

8 Swipe on the categories above the photo thumbnails, and tap on a thumbnail to add that effect

...cont'd

Hot tip

For more information about cropping photos, see pages 115-116.

Hot tip

The button in Step 11 can also be used to apply color-editing options. For more information about this, see Chapter 8.

Hot tip

For more information about making selections, see Chapter 9.

9 Tap on this button on the bottom toolbar to access options for cropping the photo

10 Tap on the **Aspect Ratio** tab to determine how the photo can be cropped. Tap on the **Unconstrained** button to allow freehand cropping, or select one of the aspect ratios, such as **Square**

11 Tap on this button on the bottom toolbar to access options for selecting areas of the photo

12 Tap on the **Selection Tools** tab to access options for selecting the main subject or the background of the photo, or by dragging over an area of the photo to select it. Selections can then be edited independently of the rest of the photo

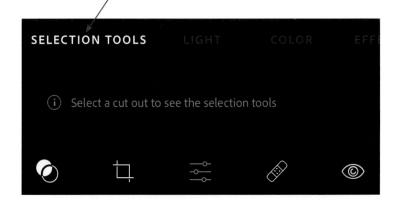

...cont'd

13 Tap on this button on the bottom toolbar to access options for removing areas in the photo

14 Areas are removed using the Brush tool. Tap here to select the size of the Brush tool and the options for how it operates. Drag the Brush tool over the affected area of the photo to replace it with another part of the photo

For more information about removing blemishes in photos, see pages 124-125.

81

15 Tap on this button on the bottom toolbar to access options for removing red eye from a person or pet in the photo

16 Tap here to select whether to remove red eye for a person or a pet, and tap on the **Auto Detect & Correct** button to remove the red eye automatically

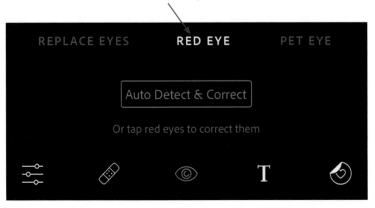

For more information about removing red eye in photos, see page 120.

...cont'd

17 Tap on this button on the bottom toolbar to access options for adding text to the photo

18 Tap on the **Styles** tab to view the available styles for adding text. Swipe along the styles to view them all

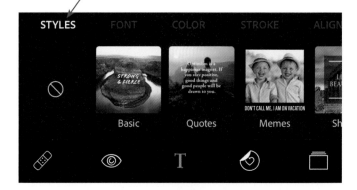

Hot tip

For more information about adding text to photos, see pages 121-123.

19 Tap on a text style to select it

20 Tap on the options on the top toolbar to select formatting options for the text, including **Font**, **Color**, and **Stroke**. Tap on the appropriate items to select them for the text

...cont'd

21 Tap on this button on the bottom toolbar to access options for adding stickers to the photo

22 Tap on a sticker to add it as a graphical element to the photo. Numerous stickers can be added to a single photo

Hot tip

For more information about adding graphical elements and creative effects to photos, see Chapter 10.

23 Tap on this button on the bottom toolbar to access options for adding frames and borders to the photo

24 Tap on the categories here to access options below for adding frames and borders. Tap on one to apply it

Snapseed

Snapseed is an excellent all-round photo-editing app that has an array of tools for enhancing photos on your smartphone and tablet. To use Snapseed:

Hot tip

If the Camera option is selected in Step 3, the photo will be captured by the device's camera and appear at full size, ready for editing, within the Snapseed app.

1 Tap on this button to open Snapseed

2 Tap on the **Open** button to access photos

3 Select where you want to access photos from. Tap on the **Open from Device** button to access the photos already on your smartphone or tablet. Tap on a photo to view it at full size

4 Tap on the **Looks** button on the bottom toolbar to access filters **LOOKS**

5 Swipe here to view the range of available filters

6 Tap on one of the filters to select it. Tap on the check mark symbol to apply it to the photo, or the cross symbol to reject it

7 Tap on the **Tools** button on the bottom toolbar to access the editing tools

TOOLS

8 Tap on one of the available tools to use it on the currently opened photo

9 Selections can be made within each editing tool – e.g. **Tune Image** options can be accessed by tapping on this button on the bottom toolbar. Within this section, tap on one of the color-editing categories to make changes as required

Don't forget

When a photo is opened at full size within Snapseed, these three buttons are available in the top right-hand corner. They can be used to, from left to right: undo or redo previous actions, or revert to the original photo; view information about the photo, including the date and time when it was taken; and access tutorials, help, information and settings.

85

10 Tap on the **Export** button on the bottom toolbar to access options for sharing, saving and exporting the current photo

EXPORT

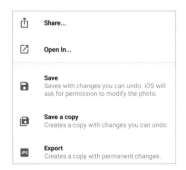

Pixlr

Pixlr is a photo-editing app that has options for color editing, adding filters, special effects, borders, and text. It can also be used to create collages. To use Pixlr:

Hot tip

Tap on this button in the top left-hand corner of any Pixlr screen to return to the Homepage in Step 2 at any point.

1 Tap on this button to open Pixlr

2 Tap on the **photos** button to access photos from your smartphone or tablet

3 Tap on a photo to view it at full size.
The editing categories are available on the bottom toolbar

4 Tap on this button on the bottom toolbar to access the editing tools. Tap on one of the options – e.g. **adjustment** for color editing

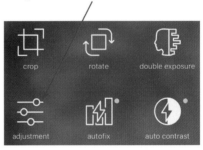

Don't forget

Tap on the check mark symbol to apply an effect or the cross symbol to reject it.

5 Tap on one of the options (e.g. **exposure**) and drag the slider to apply the amount of the selected effect

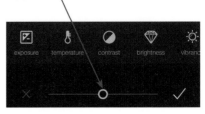

6 Tap on this button on the bottom toolbar to access the editing brushes. Tap on one of the brushes to select it

7 Make selections for the brush, including **size**, and drag the slider to specify the amount for each option. Drag over the photo to apply the brush effect

The other options in Step 7 are **feather**, which determines how the edges of an edited area merge with the rest of the photo; and **intensity**, which determines the level of the effect when you drag over the photo.

8 Tap on this button on the bottom toolbar to access the filters. Tap on one of the main categories – **effect**, **overlay**, or **stylize** – and tap here to view the sub-categories. Tap on one of the thumbnail images to apply that filter

Pixlr is free to download, but some of the functions require an annual subscription. These include some of the filter effects.

...cont'd

9 Tap on this button on the bottom toolbar to access the **borders** and **stickers**. Tap on either category to view the options, and tap on an item to apply it to an open photo

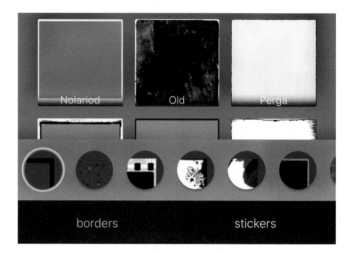

Hot tip

The slider at the bottom of the text box in Step 11 determines the opacity of the text – i.e. how much of the background appears through the text. If the slider is all of the way to the right, the text will be solid, with no background showing through the text.

10 Tap on this button on the bottom toolbar to access the text options

11 Type text onto a photo and tap on the **next** button. Make selections here for the font and style of the text

...cont'd

Creating collages

To create a collage in Pixlr:

1 Tap on the **collage** button on the Pixlr Homepage

collage

2 Tap on one of the template styles to select it for the collage

3 Tap on specific photos to select them for inclusion in the collage. Tap on the **Select** button

Options for formatting the collage are available below the example of the collage when it is created in Step 4.

4 The collage is created with the photos selected in Step 3

VSCO

VSCO is a photo-editing app that specializes in an extensive range of filters and color combinations for photos. It also has a selection of standard photo-editing tools. To use VSCO:

Don't forget

When VSCO is opened for the second time, tap on this button to get the full range of filter and editing options.

Hot tip

Tap on the button in Step 4 to access options for how the thumbnails are displayed. This can include grid options.

Don't forget

If a thumbnail has this symbol on it, it means that the filter can only be used by paying a fee to become a VSCO member.

1 Tap on this button to open VSCO

2 A sign-in is required in order to use VSCO. This can be done with an existing Facebook or Google account, or phone number or email address

3 Tap on a photo to open it at full size and access the editing options

4 Tap on this button on the bottom toolbar to access options for applying preset color combinations and filters

5 Tap on a filter to apply it to the photo

...cont'd

6 Tap on this button on the bottom toolbar to access the editing options

 Hot tip

The **Sharpen** editing option in Step 6 can be used to make a photo appear more sharply in focus.

7 Swipe along this toolbar to view all of the editing options

8 Tap on an item to access its controls. Drag on the sliders to apply the selected effect

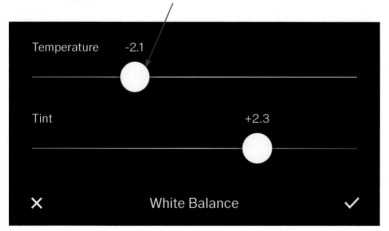

Prisma

Prisma is a photo-editing app that can be used for standard color editing, but it really comes into its own with an extensive range of filters and color themes. To use Prisma:

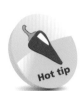

Hot tip

Tap on the **Library** button at the left-hand side of the filter thumbnails to access the full range.

1 Tap on this button to open Prisma

2 Swipe up on the **Gallery** button to view the available photos. Tap on a photo to open it at full size

3 Swipe along the filter thumbnails to view the available range. Tap on a filter to apply it

4 The filters produce a range of dramatic effects

Beware

If a filter thumbnail has a padlock on it this means that it can only be accessed with the paid-for version of Prisma, which involves a monthly or an annual subscription.

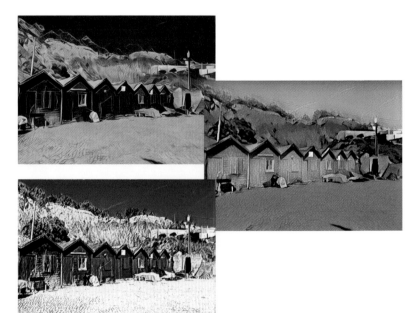

5 Tap on this button on the bottom toolbar to access the color-editing options

6 Drag the sliders to apply an effect for each item. Tap on the check mark symbol to apply an effect and tap on the cross symbol to reject it

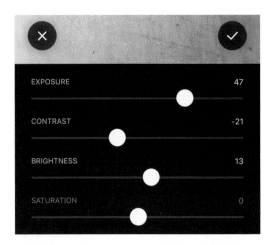

7 Swipe up the window to access more editing options

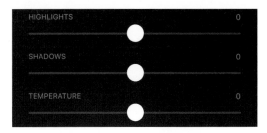

8 Tap on this button on the bottom toolbar to access the sharing options

9 Select how you want to share the photo, as required

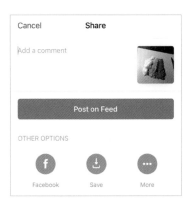

Tap on the **More** button in Step 9 to access additional options for sharing a photo, including in a text message or an email.

PhotoCollage

PhotoCollage is, as the name suggests, an app for creating eye-catching and artistic collages out of your favorite photos. To use PhotoCollage:

1 Tap on this button to open PhotoCollage

2 The photo library should be displayed. Tap on photos to select them for the collage

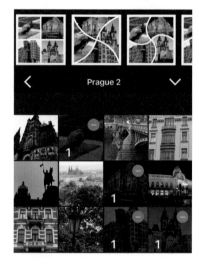

The styles at the top of the window in Step 2 change depending on the number of photos that have been selected.

3 Tap at the top of the window to select a style for the collage

For more details about creating photo collages, see pages 170-174.

4 The basic collage is created with the style selected in Step 3. Additional formatting can now be applied to the collage

5 The editing tools for the collage are on the bottom toolbar. Tap on the **Ratio** button to change the proportions of the collage

6 Tap on the **Frames** button to add a frame around the whole collage

7 Tap on the **Borders** button to edit the internal borders of the collage

8 Tap on the **Color** button to edit the colors of the collage's borders

9 Tap on the **Filters** button to apply a color filter to all of the photos in the collage

10 Tap on the **Text** button to add text in the middle of the collage

11 Tap on the **Draw** button to add freehand drawings over the whole collage

12 Tap on the **Stamps** button to add graphical elements to the collage

13 Tap on the **Emoji** button to add emojis to the collage

14 Once all of the editing changes have been made, tap on the **Save** button at the top of the window to save the completed collage

Hot tip

Once text has been added to a collage it can be formatted and resized as it appears on the collage – e.g. over the photos and borders that have been added.

Afterlight

Afterlight is an easy-to-use photo-editing app that has an impressive range of editing tools. To use Afterlight:

1 Tap on this button to open Afterlight

2 Tap on a photo to view it at full size, and tap on the **Use** button to start editing the photo

3 The editing options appear on the bottom toolbar

4 Tap on this button to access options for cropping, rotating, and straightening the photo

CROP ROTATE FLIP H FLIP V STRAIGHTEN

Don't forget

For each color-editing option, drag the slider to apply the required amount of the effect. Tap on the check mark symbol to apply the effect, and tap on the cross symbol to reject it.

5 Tap on this button to access the color-editing options. Tap on an item to select it and apply editing changes

ADJUSTMENTS TOUCH TOOLS

CURVES BRIGHTNESS CONTRAST VIBRANCE CLAR

...cont'd

6 Tap on this button to access the filter options. Tap on one to apply it to the current photo

7 Tap on this button to access the special effects

8 Tap on one of the special effects categories and make the required selections within it

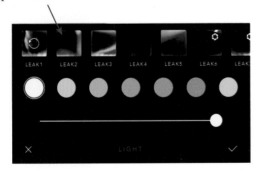

9 Tap on this button to access the text options

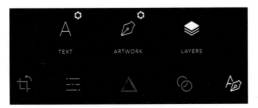

Once the editing has been completed, tap on the **Next** button at the top of the window and select options for how you want to share or save the photo. Tap on the **New** button to open another photo or take one with the camera.

PicsArt

PicsArt is a useful photo-editing app that includes a range of options for facial enhancements. To use PicsArt:

1 Tap on this button to open PicsArt

2 Tap on the **All Photos** button, and tap on a photo to open it at full size

3 The available editing categories are available on the bottom toolbar

The crown symbol indicates the PicsArt Gold option, which is a paid-for monthly or annual subscription. A three-day free trial is available.

4 Tap on the **Tools** button to access the color-editing options and other tools

5 Tap on one of the tools' main categories to select it

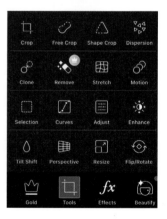

6 Select any sub-categories within the main category, and drag the slider to apply the effect

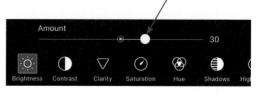

…cont'd

7 Tap on the **Effects** button, and tap on one of the effects to apply it to the whole photo

8 Tap on the **Beautify** button to access options for enhancing facial elements. Tap on an item to apply it to a face in a photo, or to access more options within that category

9 Tap on the **Sticker** button to access stickers that can be added to a photo by tapping on them. Once they have been added, they can be resized and repositioned within the photo

10 Tap on the **Cutout** button to select areas within the photo that can then be cut out and used as customized stickers

11 Tap on the **Text** button to add text to the photo

12 Tap on the **Add Photo** button to open more photos from your photo library

Beware

Several of the Beautify options require the PicsArt Gold subscription version of the app.

Don't forget

Once all of the editing changes have been made, tap on the **Next** button to access options for sharing the photo (this is saved automatically after the Next button is tapped).

Next

AirBrush

AirBrush is an app that has the standard range of color-editing tools, but it also has a selection of useful options for editing and enhancing facial features. To use AirBrush:

Don't forget

Tap on the **Camera** button in Step 2 to take a new photo with the device's camera.

1 Tap on this button to open AirBrush

2 Tap on the **Library** button and tap on a photo to open it at full size

3 Tap on the **Retouch** button to access options for applying editing changes to faces within the photo, such as removing blemishes

4 Tap on the **Tools** button to access editing tools for rotating the photo, cropping it, and applying color-editing changes to it

5 Tap on the **Makeup** button to access options for enhancing facial features, such as lip color. Tap on one of the thumbnails to select an effect, and tap on the check mark symbol to apply it

Makeup

| None | My Look | Frosty | Merry | Sparkl(|

✕ Makeup ✓

6 Tap on the **Filter** button to access filter options for the photo. Tap on a thumbnail to select the filter effect, and tap on the check mark symbol to apply it

Filter

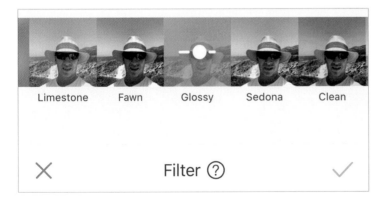

| Limestone | Fawn | Glossy | Sedona | Clean |

✕ Filter ⑦ ✓

7 Tap on this button when you have finished editing to save the photo automatically and access options for sharing it (see tip). The options from this button also include returning to the photo library or accessing the camera

Don't forget

The **Share** options that are accessed from the button in Step 7 include sharing the photo to social media sites and also via text messaging and email. Tap on these buttons as required.

Share Now

Banuba

While some photo-editing apps offer sophisticated color-editing options, others are more concerned with offering fun face effects. This is done by providing face filters that can be applied when a photo is taken. One of these apps is Banuba, which has an extensive range of face filters and effects. To use Banuba:

1 Tap on this button to open Banuba

2 Tap on the **Photo** button on the bottom toolbar

3 The app uses the front-facing camera,

so that you can take a photo of yourself with an effect applied. Swipe along the bottom toolbar and tap on a filter to apply it and take a photo. Numerous fun and bizarre filters can be applied

Hot tip

Videos can also be created with fun effects applied to them too. To do this, tap on the **Video** button instead of the Photo one in Step 2.

Funny Face

Funny Face is another app that concentrates on creating fun and humorous selfies. This is done by providing a range of facial elements that can be dragged onto a selfie that has been taken. To use Funny Face:

1 Tap on this button to open Funny Face

2 Tap on the **Tap here to add a New Photo** option

Tap here to add a New Photo

3 Tap on the **From Camera** button to take a new photo

Pick a photo
Choose from where do you want to pick a photo.

From Gallery | From Camera

4 Once the photo has been taken it will be displayed in the main window. Drag items from the bottom toolbar to add them to the photo

5 Numerous elements can be added to a photo, to give it a cartoonish effect

Hot tip

Once an element has been added to a photo, press and hold on it to drag it around the photo. Swipe outwards with thumb and forefinger to increase its size, and pinch inwards with thumb and forefinger to decrease its size.

Instagram Editing

Instagram is one of the most popular photo-sharing apps on the web. It also has options for editing and enhancing photos, before they are posted for the world to see. To do this:

1 Tap on this button to open Instagram

2 Tap on this button and tap on a photo to open it at full size

3 Tap on the **Next** button at the top of the window

4 Tap on the **Filter** button and tap on one of the filters to add it to the photo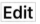

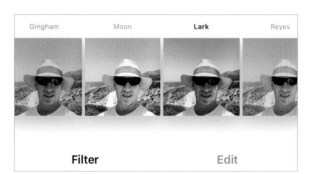

5 Tap on the **Edit** button and tap on one of the categories to access options for applying the effect to the photo **Edit**

Don't forget

Once the editing has been completed, tap on the **Next** button at the top of the window and select options for how you want to share the photo. Tap on the **Share** button to share the photo to your Instagram account.

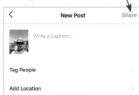

7 Editing Basics

This chapter looks at a range of photo-editing techniques that can be used to improve every photo that you take.

It looks at how to access photos with a photo-editing app, and details a range of options that can be applied: from improving the overall color of a photo with one tap, to fixing red eye in a photo.

It also shows how to add text to a photo to give it an additional feature.

Accessing Photos

Being able to access photos is one of the fundamental tasks of a photo-editing app. This can be done from a number of sources, and the most common one is accessing photos that are already in the photo library on your smartphone or tablet. When you use the photo-editing app for the first time it will ask for permission to access your photos:

The editing examples in this and the next four chapters use Photoshop (PS) Express, as it is one of the most comprehensive photo-editing apps and has options for most editing functions. Most other photo-editing apps can perform the same general editing functions as PS Express.

1 Tap on the **OK** button to give the app access to your photo library

"PS Express" Would Like to Access Your Photos

Giving access will enable you to edit photos from your photo library.

Don't Allow OK

2 The photo library is displayed. Swipe up and down to view the available photos

PS Express has a paid-for version that provides access to additional functionality within the app. This is called PS Express Premium, and it can be accessed from this button on the top toolbar within Edit mode. Items within PS Express that require the Premium version are also denoted by the same button. These features will be noted as required.

...cont'd

3 Tap on this button in the top right-hand corner of the main photo library window

4 Tap on the **Change View** button to change the default view to one where the photos are displayed at a larger size. Repeat the process to return to the default view

Change View

5 Tap here at the top of the photo library window to access more options for obtaining photos

Recents ∨

The default view in the photo library is the grid view, as shown in Step 2 on the previous page.

107

6 Tap on an item to access photos from it. This can include the camera (operated through PS Express), albums that have been created, or social media sites

...cont'd

Viewing photos

Photos from the photo library can be viewed at full size, ready for editing. To do this:

Don't forget

When a photo is viewed at full size, the editing toolbars will be available. These can be at the top or bottom of the window, or both.

1 Tap on a photo in the photo library to view it at full size, within Edit mode

Don't forget

When a photo is being viewed in Edit mode, tap on this button on the top toolbar to go back to the photo library.

2 Tap on this button in the top right-hand corner of the window, and tap on the **Show Info** button to display details about the photo

3 Details about the photo include the file size, the date and time when it was taken, and the device on which it was captured

(i) INFO

IMG_2071.HEIC
11.63 MP, 3024 x 4032, 1.33 MB

04-Oct-2019
Friday, 15:03

iPhone XS
f/1.8 1/1954s 4.25mm ISO25

Zooming in and out

Being able to zoom in and out on a photo is an important aspect of photo editing: zooming in can enable editing changes to be made to specific areas, and zooming out enables an overview of editing changes that have been made. To do this:

1 To zoom in on a photo, swipe outwards with thumb and forefinger, or double-tap on the photo

2 To zoom out on a photo, pinch inwards with thumb and forefinger, or double-tap on the photo

Hot tip

Zooming in and out by double-tapping performs the zoom task to a specific amount. Zooming by swiping or pinching with thumb and forefinger enables a greater amount of zoom to be applied.

Hot tip

When a photo has been zoomed in on, you can move around it by dragging with one finger over the photo.

109

Settings

Photo-editing apps have a range of settings that can be applied to the operation of the app. Several of these are connected with options for sharing photos. To access the settings:

Hot tip

For some photo-editing apps, the **Settings** are accessed from this button.

1 Tap on the Menu button on the Homepage

2 General settings are displayed

3 Tap on the **Preferences** option to access more settings

4 Tap on each item as required. This includes linking to social media accounts, and you can sign in to the relevant account within the Settings section so that photos can then be shared with the account

Toolbars for Editing

The editing functionality within photo-editing apps is contained within toolbars. These can be located at the top or the bottom of the editing window, or both, and can be used to perform single editing tasks, or ones with several steps. To access editing toolbars:

1 Within Edit mode, tap on a photo to view it at full size. The top toolbar contains options to, from left to right: undo the previous action; redo the previous action; apply instant color editing to the whole photo; view Before and After examples for the current editing effect; access PS Express Premium; and share the photo

Hot tip

The **Before and After** button is a great way to view editing effects as compared with the original photo. The original photo is always the one that is displayed as the Before option, regardless of how many editing changes have been made, unless the edited version has been saved as a new photo.

2 The bottom toolbar contains the main photo-editing categories, with their options above

3 Swipe along the bottom toolbar to view the full range of editing options

Saving Photos

Once editing changes have been made to a photo it is important to save the edited photo, so that the changes are retained. This is done by creating a new photo, with the original remaining unchanged. It is possible to save photos to different locations and in different formats. To save photos:

1 Edit a photo and tap on this button on the top toolbar

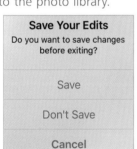

Don't forget

If you tap on the **Back** button to go back to the photo library, before a photo has been saved, you will be prompted to do so. Tap on the **Save** button to save the photo directly to the photo library.

Save Your Edits

Do you want to save changes before exiting?

Save

Don't Save

Cancel

2 The Save & Share dialog box contains a variety of options for saving photos

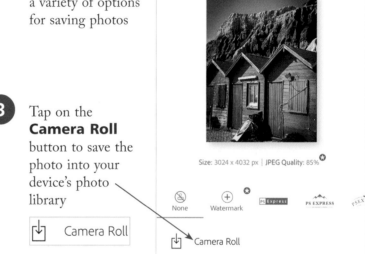

3 Tap on the **Camera Roll** button to save the photo into your device's photo library

Camera Roll

4 The saved photo becomes the most recently available in the photo library

Saving to other locations

To save photos to locations other than the photo library:

1 Swipe up the Save & Share dialog box to access options for sharing the photo to social media sites

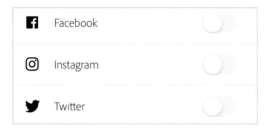

2 Tap on a social media site and log in to the site within the PS Express app (the button turns blue once a connection to the account has been made)

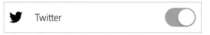

Hot tip

If several social media accounts are added in Step 2, the photo will be uploaded to all of them from the **Save & Share** button in Step 3.

113

3 Tap on the **Save & Share** button to share the photo to the selected social media site

Save & Share

4 Swipe up the Save & Share dialog window to access more sharing options, including saving the photo as a PDF file or sending it in a messaging app or in an email

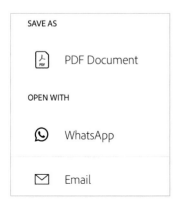

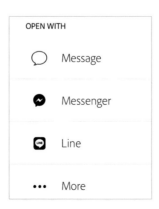

One-tap Auto-Enhance

Some photo editing can involve several different options and take a reasonable amount of care and attention. However, quick and effective editing effects can be made to a photo in a single tap. To do this:

1 Open a photo at full size

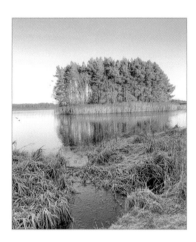

Don't forget

The Auto-Enhance option is a good way to quickly edit the colors in a photo. However, a more satisfying result can be achieved by editing each color element individually (see Chapter 8 for details).

2 Tap on the **Auto-Enhance** button on the top toolbar

3 A range of color-editing effects are automatically applied to the whole photo

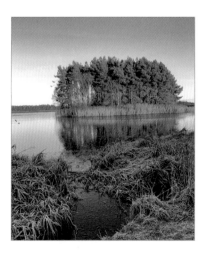

Cropping Effectively

Cropping a photo involves selecting an area of the photo that you want to retain, and discarding the rest. This can be done with a range of rectangular selection options. To crop a photo with either a freehand selection or a preset one:

1 Open the photo you want to crop at full size

2 Tap on this button on the bottom toolbar

3 Tap on the **Aspect Ratio** tab and tap on the **Unconstrained** button to crop the photo vertically and horizontally

4 Drag the resizing handles at each corner so that the area you want to retain is within the rectangle

Don't forget

Once a photo has been cropped, it can be saved as a new photo as shown on pages 112-113. To continue editing the photo, tap on another editing option. The cropped photo will be available for further editing.

...cont'd

Device

5 Swipe along the **Aspect Ratio** options in Step 3 on page 115 to select options that constrain the cropped area to a specific ratio (e.g. **Device**) to match the size of the device being used

Beware

If a photo is cropped for a specific device it may not look the same in terms of its aspect ratio when viewed on a different device.

6 The photo is automatically cropped to fit the screen area of the device on which it is being viewed

7 Swipe along the **Aspect Ratio** options to view the full selection, including being able to crop photos so that they are in a ratio to fit standard photo frames – e.g. 7 x 5 inches

Cropping for Social Media

Social media sites usually have an option for adding photos to your own page once you have created an account. Most of these are set to specific ratios, and it can be difficult to create photos to the precise ratios without them being distorted. However, photos can be cropped to fit specific social media sites. To do this:

1 Open a photo at full size and access the **Crop** tool as shown on page 115

2 Swipe along the **Aspect Ratio** options and tap on a social media option, as required

ASPECT RATIO	ROTATE	TRANSFORM
Square FB Profile	FB Profile Cover	FB Page Cover

3 The crop area for the selected option is displayed over the photo. Press on the crop area and drag it to move it over another area of the photo (the crop area remains the same wherever it is positioned)

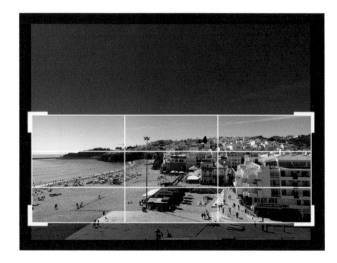

Hot tip

Photos can be cropped for a range of social media options, including Facebook, Instagram, Twitter, LinkedIn, Pinterest, and YouTube.

Hot tip

Once a photo has been cropped for a social media site it can be uploaded directly to the site as shown on page 113, by tapping on this button.

Rotating Photos

Photo-editing apps can rotate photos in a number of different ways, and also straighten them if objects within them appear distorted. To do this:

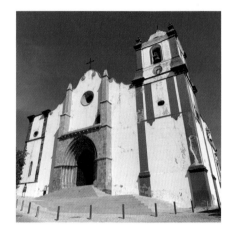

The **Rotate** option rotates a photo clockwise in 90-degree increments.

1 Open a photo that needs to be straightened or rotated

2 Tap on this button on the bottom toolbar, tap on the **Rotate** tab and select one of the options – e.g. **Straighten**

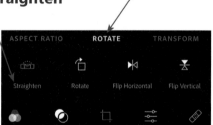

If the **Straighten** option is used to straighten an object in a photo, such as a tower, the rest of the elements in the photo will be straightened too, to apply the effect so as to get the best balance for the whole photo.

3 For the Straighten effect, drag this slider to straighten the elements of the photo. The area within the grid is the one that will be used for the final photo

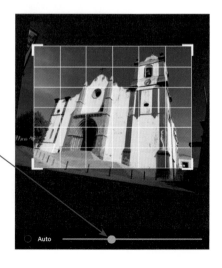

Transforming Photos

Photos can be edited with the Transform option to distort the image and give it a different perspective. To do this:

1 Open a photo at full size and tap on this button on the bottom toolbar

2 Tap on the **Transform** tab and select one of the transform options

3 Drag the slider at the bottom of the window to apply to selected effect to the photo

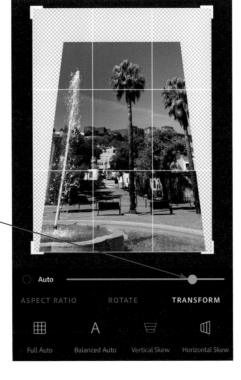

The final image from the transform process includes the whole photo with the transform effect applied, but not the light border that appears as the photo is being transformed, as in Step 3.

Fixing Red Eye

Red eye, where a subject's eyes appear red due to a reflection from the camera's flash, is less common in photos these days, due to the sophisticated nature of cameras, including those on smartphones and tablets. However, it can still occur and, if it does, it can be removed with a photo-editing app. To do this:

Beware

Even when the Red Eye function replaces the red eye, it may not create the correct eye color for the subject.

1 Open a photo that contains red eye

2 Tap on this button on the bottom toolbar

Hot tip

If the manual option is chosen, zoom in on the eyes by swiping outwards with thumb and forefinger to enable the process to more be precise.

3 Tap on the **Red Eye** tab and tap on the **Auto Detect & Correct** button to automatically fix red eye, or

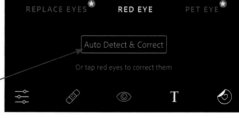

4 Tap on an eye with red eye to remove it. Repeat the process with the other eye

120

Don't forget

The other red eye options are Replace Eyes, which enables you to replace the eyes affected by red eye with eyes from another photo; and Pet Eye, which replaces red eye in animals. Both of these require PS Express Premium.

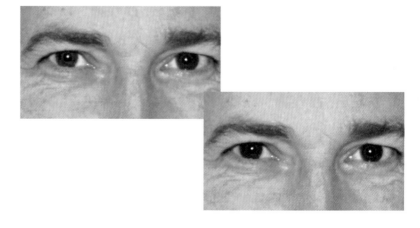

Text Options

An effective way of enhancing photos is adding textual elements. These can provide extra information about the photo, or just be a fun addition. To add text to a photo:

1 Open a photo that has a suitable area for adding text

2 Tap on this button on the bottom toolbar

3 Tap on the **Styles** tab to view the main text style categories

4 Tap on one of the styles to view its sub-categories. Tap on one of these to apply it to the photo

Hot tip

When adding text, make sure that there is a good contrast between the text color and the background.

Don't forget

Some text styles include a border around the text; for others it is just the text on its own.

...cont'd

Hot tip

If a text box is expanded, the text will fill the available space – e.g. if the text is on two lines and the text box is expanded, the text will move to a single line as soon as the text box is large enough.

Hot tip

Drag on this button to rotate the text box, and the text within it.

5 A text box with default text added is inserted on the photo, using the style selected in Step 4 on page 121. Drag on this button to resize the text box

6 Tap on the text box or tap on this button to access Text Editing mode

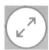

7 Enter new text as required, and tap on the **Done** button

8 The new text is added to the text box on the photo

...cont'd

9 Tap on the **Font** tab and tap on a font style to select it for the current text

10 Tap on the **Color** tab and tap on a color to select it for the current text

11 The font and color selections are applied to the text

Tap on this button to delete the text box, and the text within it.

123

12 Tap on the **Stroke** tab and select a color for the stroke – i.e. the outline around the text

13 Drag this slider to change the thickness of the stroke around the text

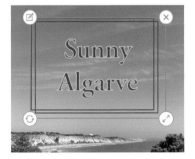

Removing Blemishes

Photo-editing apps are proficient at removing unwanted items, particularly physical blemishes such as spots and wrinkles. This is done with the Brush tool, which automatically copies an area of the photo over the one affected by the blemish. There are Basic and Advanced options for removing blemishes.

Basic

Hot tip

Zoom in on the affected area by swiping outwards with thumb and forefinger to edit the blemish with greater accuracy.

124

Don't forget

The slider in Step 3 determines the size of the Brush tool, which is denoted by a circular blue outline.

1 Open an image with blemishes that you want to remove

2 Tap on this button on the bottom toolbar

3 Tap on the **Basic** button and drag this slider to specify the size of the Brush tool (see Don't forget tip)

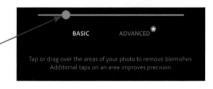

BASIC ADVANCED*

Tap or drag over the areas of your photo to remove blemishes. Additional taps on an area improves precision.

4 Drag the Brush tool over the affected area. As it moves over the photo, the area covered by the Brush tool is colored red

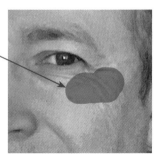

5 The blemish is removed, and other areas of the photo are blended with the affected area

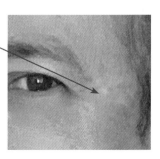

...cont'd

Advanced

1 Open an image with blemishes that you want to remove, as in Step 1 on the previous page

2 Tap on this button on the bottom toolbar

3 Tap on the **Advanced** button and tap on the **Size** button. Drag the slider to determine the size of the Brush tool

4 Tap on the area of the photo where you want to remove a blemish. Two circular blue outlines appear: the lower one is the area that is copied when the top one is moved. Drag the top circle to copy over the area beneath the second circle

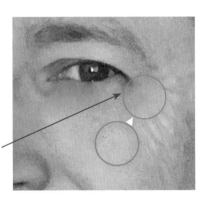

5 Tap on the **Opacity** button in Step 3 to determine how much of the background shows through the edited area

6 Tap on the **Feather** button in Step 3 to determine how the edges of the blended area merge with the background

The Advanced options for the Brush tool require PS Express Premium in order to save photos that have been edited in this way.

Ensure the **Blend** button is **On** (blue) in Step 3 so that the background and the area being copied can blend together.

The degree to which both Opacity and Feather are applied is determined by dragging the same slider as in Step 3.

Sharpening Focus

Sharpening in a photo-editing app refers to improving the focus of the photo if it is slightly blurry. It does this by increasing the contrast between the individual pixels in a photo, and the overall effect can make it appear more sharply in focus. To apply sharpening to a photo:

Don't forget

Pixels are the small colored dots that make up digital images.

1 Open a photo that is slightly out of focus (it is best to zoom in on the photo by swiping outwards with thumb and forefinger to check the focus in detail)

2 Tap on this button on the bottom toolbar

3 Tap on the **Details** tab **DETAILS**

4 Tap on the **Sharpen** thumbnail

Beware

The sharpening option can only do so much in terms of making photos look more sharply in focus. If a photo is too blurry it probably will not be able to be saved, even with sharpening.

5 Drag the slider to sharpen the focus of the photo

6 The sharpened photo may not be completely in focus, but it should be better than the unsharpened version

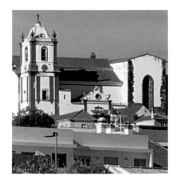

Blurring Focus

The opposite of sharpening a photo is deliberately blurring it. This can be done to create an artistic effect that could have other elements placed over it, such as text. To blur a photo:

1 Open a photo that you want to blur

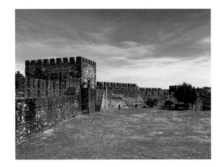

Hot tip

To exaggerate the blur effect, perform the blurring operation and save the blurred photo. Open the newly saved photo and apply the blur effect again.

2 Tap on this button on the bottom toolbar

3 Tap on the **Blur** tab **BLUR**

4 Tap on the **Full** button

Full

5 Drag the slider to blur the photo as required

SPLIT TONE **BLUR** VIGNETTE

Radial Full

Hot tip

The other blur option is **Radial**, which can be used to exclude a circular area from the blurring effect: the area within the circle remains in focus, and the background becomes blurred. This can be used to blur the background behind a face.

Reverting to Original

When editing a photo it is useful to return to the original version, if you do not want to keep the edits that you have made. This can be done in two ways:

From the Menu button

1 While editing a photo, tap on this button on the top toolbar

2 Tap on the **Revert to Original** button

Revert to Original

3 Tap on the **Continue** button

> **This will remove all your edits. Do you want to continue?**
>
> Cancel Continue

From the Back button

Edits that have been made can be discarded by returning to the photo library:

1 While editing a photo, tap on the **Back** button on the top toolbar

2 Tap on the **Don't Save** button to discard any editing changes that have been made

> **Save Your Edits**
> Do you want to save changes before exiting?
>
> Save
>
> Don't Save
>
> Cancel

Don't forget

Editing changes can also be removed by tapping on the **Undo** button on the top toolbar. This can be done for all of the editing changes that have been made, before the photo has been saved.

(8) Color Editing

Color editing is one of the fundamental tasks of a photo-editing app, and this chapter looks at the range of options that are available. These include improving the overall exposure of a photo, and editing the dark and light areas with shadows and highlights.

About Color Editing

Color and light are essential parts of photography, and being able to edit these elements of a photo within a photo-editing app is a great asset in terms of fine-tuning the overall look of a photo. Different color and light elements can be edited independently of others, and some of them include:

- **Exposure**. This edits the overall amount of light in a photo.

- **Contrast**. This edits the contrast between dark and light colors in a photo.

- **Highlights**. This edits the lightest range of colors in a photo.

- **Shadows**. This edits the darkest range of colors in a photo.

- **Whites**. This edits the white areas in a photo.

- **Blacks**. This edits the black areas in a photo.

- **Temperature**. This refers to properties of light in a photo: a low-color temperature is warmer; high is cooler.

- **Tint**. This refers to the effect of having a single color dominating a photo.

- **Vibrance**. This refers to the intensity of the more muted colors in a photo.

- **Saturation**. This refers to the intensity of colors in a photo.

When editing color and light elements within a photo, the amount of the effect can be applied by dragging the slider linked to the effect:

In PS Express, Exposure, Contrast, Highlights, and Shadows are under the **Light** category. Whites, Blacks, Temperature, Tint, Vibrance, and Saturation are under the **Color** category.

Exposure

To edit the exposure in a photo:

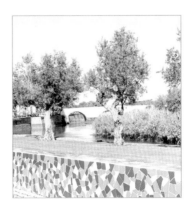

1 Open a photo at full size. Ideally this should be one where the exposure is too light or too dark

2 Tap on this button on the bottom toolbar

3 Tap on the **Light** tab

4 Tap on the **Exposure** thumbnail

5 Drag the slider to edit the exposure in the photo

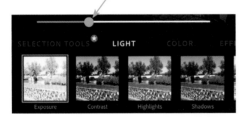

6 The effect is applied to the photo as the slider is being dragged

Beware

If areas of a photo are too dark or too bright (known as being burned-out, as there is very little color in the area), it may not be able to be suitably enhanced, even with the Exposure option.

131

Contrast

To edit the contrast in a photo:

1 Open a photo at full size. Ideally this should be one where the colors look slightly faded or "washed out"

Hot tip

If the Auto-Enhance editing option is used (see page 114), the contrast is one of the elements in the photo that will be adjusted automatically.

2 Tap on this button on the bottom toolbar

3 Tap on the **Light** tab

4 Tap on the **Contrast** thumbnail

5 Drag the slider to edit the contrast in the photo

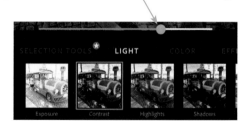

6 The effect is applied to the photo as the slider is being dragged

Highlights

To edit the highlights (light areas) in a photo:

1 Open a photo at full size. Ideally this should be one where the light areas are too bright or too dark

133

2 Tap on this button on the bottom toolbar

3 Tap on the **Light** tab

4 Tap on the **Highlights** thumbnail

5 Drag the slider to edit the highlights in the photo

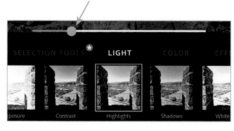

6 The effect is applied to the photo as the slider is being dragged

Hot tip

Editing highlights in a photo can be done when light areas are either too bright or too dark.

Shadows

To edit the shadows (dark areas) in a photo:

1 Open a photo at full size. Ideally this should be one where the dark areas are too dark or too light

Beware

If the Shadows editing effect is applied to a significant degree to lighten a photo, the result may look slightly speckled, due to the pixels in the photo having to be lightened so much.

2 Tap on this button on the bottom toolbar

3 Tap on the **Light** tab

4 Tap on the **Shadows** thumbnail

5 Drag the slider to edit the shadows in the photo

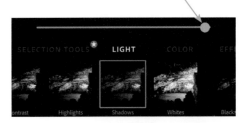

6 The effect is applied to the photo as the slider is being dragged. For dark photos, the slider may have to be dragged all of the way to the right in order to make the photo look light enough

Whites

To edit the white areas in a photo:

1 Open a photo at full size. Ideally this should be one where there is a significant amount of white in the photo

2 Tap on this button on the bottom toolbar

3 Tap on the **Light** tab

4 Tap on the **Whites** thumbnail

5 Drag the slider to edit the white areas in the photo

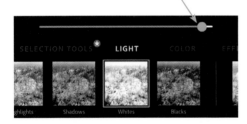

6 The effect is applied to the photo as the slider is being dragged. For the Whites effect, the white elements of the photo will be enhanced

135

Hot tip

The Whites editing effect works best on items whose color is actually white, rather than items that are lightly colored. If this is the case, another editing option, such as highlights, could be more effective.

Blacks

To edit the black areas in a photo:

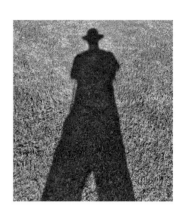

1 Open a photo at full size. Ideally this should be one where there are dark areas that you want to enhance

Don't forget

The dark areas of a photo can also be edited using the Shadows option, but this will adjust all of the dark areas, not just the black areas in the photo.

2 Tap on this button on the bottom toolbar

3 Tap on the **Light** tab **LIGHT**

4 Tap on the **Blacks** thumbnail

5 Drag the slider to edit the black areas in the photo

6 The effect is applied to the photo as the slider is being dragged

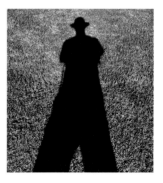

Temperature

To edit the color temperature in a photo:

1 Open a photo to which you want to apply a temperature effect – i.e. make the photo look cooler or warmer

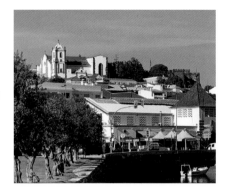

2 Tap on this button on the bottom toolbar

3 Tap on the **Color** tab COLOR

4 Tap on the **Temperature** thumbnail

5 Drag the slider to the left to make the photo look cooler, or drag the slider to the right to make the photo look warmer

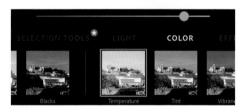

Don't forget

If the slider is dragged to the right in Step 5, the reds, oranges, and yellows in the photo will be exaggerated, giving the photo a warmer appearance. If the slider is dragged to left, the blues, purples, and greens will be exaggerated, giving the photo a cooler appearance.

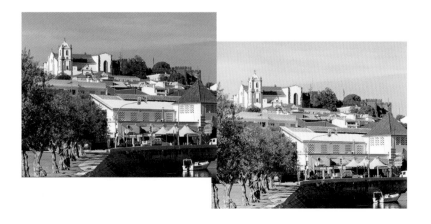

Tint

To edit the color tint in a photo:

1 Open a photo to which you want to apply a tint effect

Hot tip

The **Tint** option is best used to create artistic effects, rather than realistic ones.

138

2 Tap on this button on the bottom toolbar

3 Tap on the **Color** tab

4 Tap on the **Tint** thumbnail

5 Drag the slider to either the far left or the far right to produce dramatically different tint effects in the photo

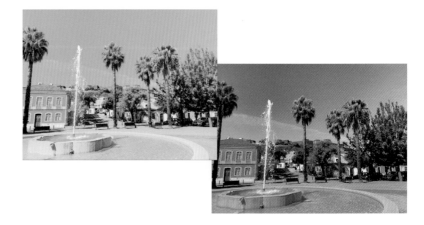

Vibrance

To edit the color vibrance in a photo:

1 Open a photo to which you want to apply a vibrance effect

2 Tap on this button on the bottom toolbar

3 Tap on the **Color** tab **COLOR**

4 Tap on the **Vibrance** thumbnail

5 Drag the slider to either the far left or the far right to enhance or remove the colors in the photo

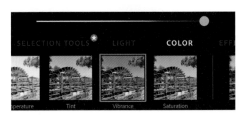

Beware

The **Vibrance** option does not remove all of the color in a photo. If you want to create a black-and-white version of a color photo, a better option is to edit the saturation (see page 140).

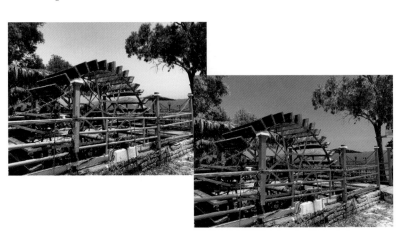

Saturation

To edit the color saturation in a photo:

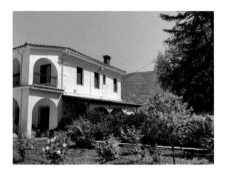

1 Open a photo to which you want to apply a saturation effect

2 Tap on this button on the bottom toolbar

3 Tap on the **Color** tab **COLOR**

4 Tap on the **Saturation** thumbnail

5 Drag the slider to edit the color saturation of the photo. Drag the slider to the far left or the far right to exaggerate or remove the colors in the photo

Hot tip

Drag the slider all of the way to the left to create a black-and-white photo. Black-and-white photos can also be achieved with one of the filter features (see page 158).

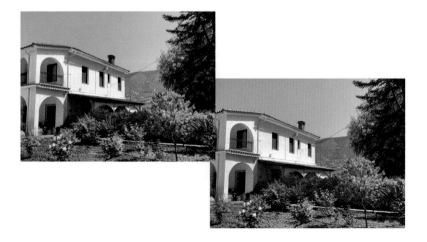

9 Making Selections

About Selections

Being able to select items and areas within a photo is a useful option to have available when editing photos. Using photo-editing apps, selections can be made in different ways:

- Automatic selections can be made for the background or the main subject in a photo.

- Areas can be selected by dragging over them.

- A smart brush can be used to specify areas to be selected.

Once an area has been selected it can be edited independently from the rest of the photo. For instance, if the main subject in a photo is selected, it can be edited without affecting any other part of the photo – i.e. the sky remains unchanged:

Don't forget

Selected areas appear red, but this is just an indicator and does not appear on the final photo once it has been edited and saved.

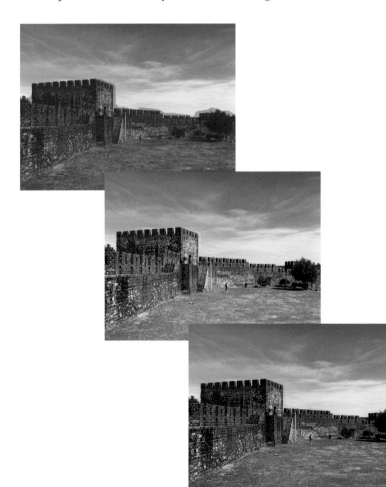

Using Selections

The selection functions of photo-editing apps on smartphones and tablets are not as sophisticated as those for apps on desktop computers or laptops. However, there is still a range of useful options for making selections. To access the selection tools:

1 Tap on this button on the bottom toolbar

2 Tap on the **Selection Tools** tab

3 The manual selection tools are shown below the Selection Tools tab. These include: the **Smartcut** tool for making a selection by dragging a rectangle over an area of a photo; the **Brush** tool for making freehand selections by dragging over a photo; and the **Refine** tool for editing an existing selection

4 Tap on this button to show or hide the auto-selection tools. These include options for selecting the subject in a photo or the background (see pages 144-145)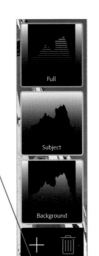

In order to make selections and save the edited photos, PS Express Premium is required.

143

Tap on this button in the Selection Tools panel to add or remove areas from an existing selection.

Auto Selections

Photo-editing apps can be used to select areas automatically, and once a selection has been made in this way it can be added to or subtracted from using manual tools. To make automatic selections within a photo:

Automatic selections work best when there is a good contrast between the main subject and the background.

1 Open a photo at full size

2 Tap on this button on the bottom toolbar

3 Tap on the **Selection Tools** tab

Once an area has been selected it can be edited independently from the rest of the photo.

4 Tap on the **Subject** thumbnail

5 The main subject is selected automatically, indicated by the red mask over it

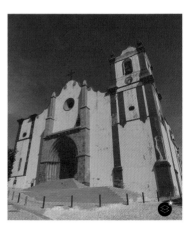

6 Tap on the **Background** thumbnail

7 The photo's background is selected automatically, indicated by the red mask over it

Beware

The Background selection option may select some of the foreground too.

Don't forget

The background areas that are selected are not necessarily joined – i.e. they could occur in different parts of the photo.

8 Tap on the **Full** thumbnail to return to the original photo, with the selections removed

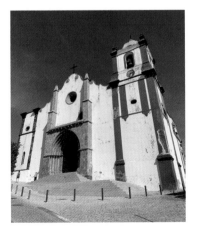

Making a New Selection

When a photo is opened in Edit mode, new selections can be made within it, regardless of the automatic background or main subject selections. To do this:

1 Open a photo and access the selection tools as shown on page 144. Tap on this button in the panel that is displayed over the photo

2 Drag over an area of the photo to make a new selection

When the rectangle is drawn over the photo in Step 2, it recognizes the object and makes the selection accordingly, so that the object alone is selected. This is a good way to select a person's face in a photo.

146

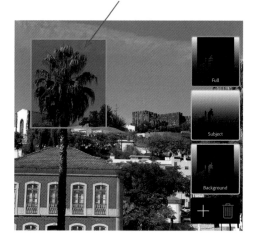

3 The selection is indicated by a red mask over it, and shown in the panel over the photo as a new selection area

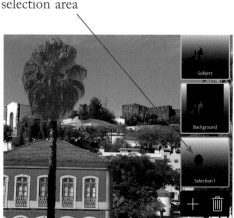

Smartcut Selections

Once a selection has been made, either with the automatic background or subject option, or the method on the previous page, selection tools can be used to add areas to the selection, or remove them. One tool for doing this is the Smartcut tool. To use it:

1 Once a selection has been made in a photo, tap on the **Smartcut** tool in the **Selection Tools** panel

2 Tap here to select whether to add to or remove from the selection

3 To add an area, drag the **Smartcut** tool over the area to be selected

4 The Smartcut tool makes the selection and it is added to the area that is already selected

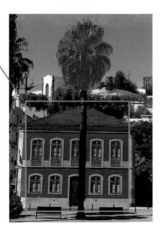

The Smartcut tool operates in the same way as when a new selection is made, as shown on the previous page.

Brush Selections

The Brush tool is another option for making specific selections within a photo. To use it:

1 Zoom in on an area of a photo by swiping outwards with thumb and forefinger, to make it easier to make the selection

Hot tip

If a smaller brush size is used for the Brush tool, a more precise selection can be made. However, a smaller brush size takes longer to select areas in a photo.

2 Tap on the **Brush** tool within the **Selection Tools** panel

3 Drag the slider to specify the size of the Brush tool. This is indicated by a blue circular icon on the photo

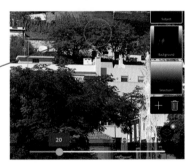

4 Drag the Brush tool over the area to be selected

5 The selection is indicated by a red mask over the area

Removing Selections

As well as adding areas to be selected within a photo, it is possible to remove a selection once it has been added. This can be a whole object, or just removing a selection that has overlapped between two areas of a photo – e.g. the sky and the photo's subject. To remove areas that have been selected:

1 Tap on this button in the **Selection Tools** panel so that it displays **Remove**

2 Drag over a selection to remove it. This can be done with the Smartcut tool (using a rectangular box to cover the area of the selection to be removed), or with the Brush tool by dragging over the selected area to be removed

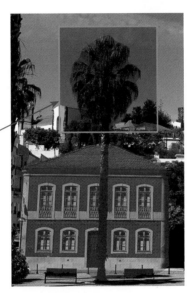

Hot tip

If the selection tools are in Remove mode, they will have a small minus sign next to them.

Smartcut Brush

149

3 The selection is removed, as indicated by the disappearance of the red mask over the area

Refining Selections

Making selections in photos is not always an exact science, and sometimes they are not as accurate as required: a selection could overlap another area, or not cover enough of the intended area. If this happens it is possible to increase or decrease the selection:

1 Access a selection area to be refined

Beware

The Refine option only changes the selection area by small amounts. If a selection has a significant overlap over another area of the photo it may be better to remove the selection and do it again.

2 Tap on the **Refine** button in the **Selection Tools** panel. Drag the slider to increase or decrease the selection area

3 The selection area is increased or decreased according to the action performed in the previous step

(10) Creative Effects

Adding creative elements with a photo-editing app can take your photos to the next level in terms of displaying and sharing them. This chapter shows some of the ways in which you can create stunning results.

Using Themes

Photography is an artistic medium, and photo-editing apps enable you to be creative in a range of ways with photos once they have been taken. One option is to apply preset themes to photos. This can include lighting effects, borders, and text boxes. To add themes to a photo:

1 Open a photo at full size

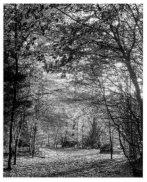

2 Tap on this button on the bottom toolbar

3 The theme categories are shown in thumbnails above the themes button

4 Swipe along the thumbnails to view the full range of theme categories

5 Tap on a category thumbnail to view the options within the category (each category has several sub-categories that can be applied)

Don't forget

If a theme has this icon on it, it means that PS Express Premium is required in order to apply it and save the photo with the theme.

6 Tap on a thumbnail to view the theme

Landscape8

7 Tap on another theme as required. Each theme is applied to the original photo – i.e. the previous theme is removed when the current one is applied

Landscape9

Hot tip

Use photos that match the category title for the themes – e.g. use **Landscapes** for country scenes and **Portraits** for photos of people.

153

...cont'd

8 Select a theme as required. It will be displayed with the lighting effects and any text boxes that are associated with the theme

9 Tap on a text box to select it. Tap on this button to edit the text

Don't forget

Tap on this button to delete an existing text box from the theme.

10 The current text is highlighted

Cancel			Done
Cut	Copy	Look Up	Share...

• Sunset lovers •

11 Enter new text as required and tap on the **Done** button

Cancel Done

• Peace in the trees

12 The new text is added to the theme

13 Press and hold on the text box and drag it into a new position in the photo

Don't forget

If a text box is expanded or contracted, using the button in Step 14, the text will be resized accordingly.

14 Drag on this button to resize the text box

Adding Filter Effects

Filter effects can transform the most mundane photo into something that is truly stunning and worthy of showing to your family and friends. Filters can be applied when a photo is taken, but there is a larger range of options within photo-editing apps:

1 Open a photo at full size

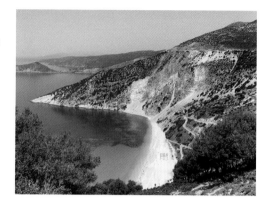

Don't forget

There is a large range of filter effects and, in general, they should be used for creating artistic photos, rather than being used for realistic photo editing.

2 Tap on this button on the bottom toolbar

3 Swipe along the thumbnails to view the full range of filter categories. Each option has sub-categories

Basic Charm White Balance Matte

Portrait Nature Pop Color Duo Tone

4 Tap on a thumbnail to view the sub-categories within that filter effect. Swipe here to view all of the options

5 Tap on one of the options to apply it to the photo

Don't forget

If a filter has this icon on it, it means that PS Express Premium is required in order to apply it and save the photo with the filter.

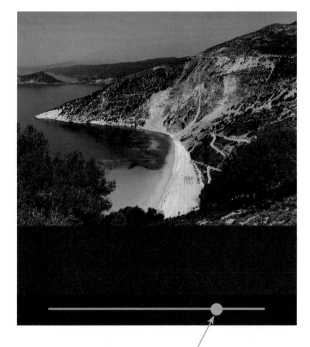

6 Drag the slider below the photo to alter the intensity of the filter effect

Creating Black and White

Black-and-white photos can be some of the most artistic and evocative. Color photos can be converted to black and white using a photo-editing app. To do this:

1 Open a photo at full size. Ideally this should be one where there is a good contrast between the light and dark areas

2 Tap on the **Filter** button on the bottom toolbar

3 Swipe along the filter thumbnails and tap on the **B&W** thumbnail

4 Tap on one of the black-and-white thumbnails to apply the effect to the photo

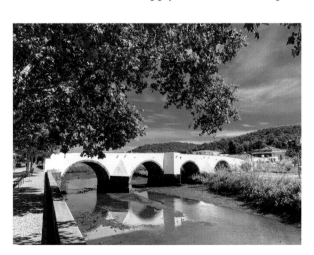

Don't forget

If a black-and-white effect has this icon on it, it means that PS Express Premium is required in order to apply it and save the photo with the effect.

Hot tip

The black-and-white filters also have sepia options, which create an old-fashioned appearance for photos. These require PS Express Premium.

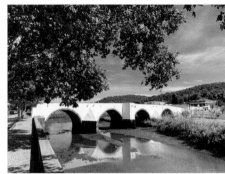

Designing Wallpaper

Photos can be edited creatively so that they can be used as wallpaper on your smartphone or tablet – i.e. the background image for your device's Homepage and also the Lock screen. To create wallpaper photos:

1 Open a photo at full size

Beware

Depending on the size of your smartphone or tablet screen, a wallpaper photo may have to be stretched to fit the screen, and so it may appear distorted.

159

2 Tap on this button on the bottom toolbar

3 Tap on the **Wallpaper** tab **WALLPAPER**

4 Swipe along the thumbnails and tap on one to select it

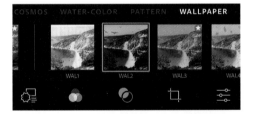

5 The wallpaper effect is added to the photo. Drag the slider to alter the intensity of the effect

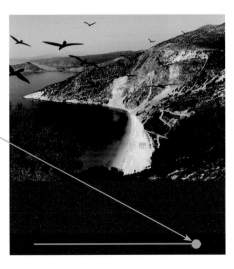

Creative Lighting Effects

Lighting effects can be added to an entire photo using the **Light** filter. In addition, specific lighting effects can be added to parts of a photo, such as a sun flare or lens glare. To do this:

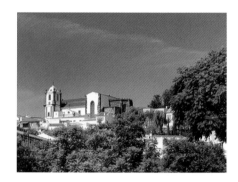

1 Open a photo at full size

Hot tip

Lens glare is the effect of light appearing in a photo as a result of reflecting with the camera's lens. This can be added as a filter or it can occur when a photo is taken. It can be an artistic feature, but sometimes it is unwanted. To avoid unwanted lens glare, hold your hand over your smartphone to shade the camera when you are taking a photo, particularly into the sun. However, make sure that you do not obstruct the camera lens.

2 Tap on this button on the bottom toolbar

3 Tap on the **Light-Leaks** tab LIGHT-LEAKS

4 Swipe along the thumbnails to view the full range of Light-Leaks options. Each option has sub-categories

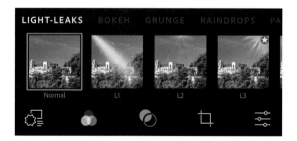

5 Tap on a thumbnail to apply the lighting effect to the photo

6 Drag the slider below the photo to apply the amount of the lighting effect

7 The Light-Leak effects can produce a range of creative and artistic photos

Don't forget

Select appropriate photos for the Light-Leak effects – e.g. do not use a night scene to add a sun-flare effect.

Adding Stickers

Stickers are a fun way to add a humorous quality to your photos. To add stickers:

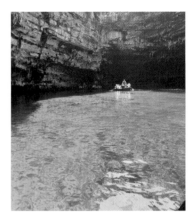

1 Open a photo at full size

Beware

Do not include too many stickers, otherwise it may detract from the photo.

2 Tap on this button on the bottom toolbar

3 Swipe along the thumbnails to view the full range of sticker options

Don't forget

After a category has been expanded, tap on the main category thumbnail again to contract it.

4 Tap on a category to expand it and view its options

5 Tap on a sticker thumbnail to add it to the photo

A7

6 The sticker is automatically inserted near the middle of the photo

Don't forget

Tap on this button to delete a sticker from the photo.

7 Press and hold on the sticker and drag it to a new location within the photo

Don't forget

Drag on this button to rotate a sticker in the photo.

8 Drag on this button to resize the sticker

Hot tip

Some photo-editing apps also have an option for adding emojis – the small graphical symbols that are found on smartphones and tablets. The process for this is similar to adding stickers to a photo.

Adding Borders and Frames

Frames and borders can be added to photos in photo-editing apps, and this gives them an additional artistic quality, like a framed photo or painting that is on display. To add borders and frames:

1 Open a photo at full size

Don't forget

Once a photo with a frame is saved, the frame becomes part of the photo. If another frame is applied, it is done so with the existing frame in the photo – it does not replace the existing frame.

2 Swipe along the bottom toolbar and tap on this button

3 Tap on the **Basic** tab **BASIC**

4 The Basic frames are displayed. Tap on one to apply it

5 Tap on the **Edges** tab and select an option **EDGES**

...cont'd

6 The selected option is applied to the photo. Tap here at the bottom of the photo to change the color of the edges

Film

Hot tip

Tap on this button at the bottom of the window in Step 6 to access a color wheel where you can create your own customized colors that can then be used for the edges or a frame.

7 Tap on the **Frames** tab and select an option

FRAMES

165

8 The selected option is applied to the photo. Tap here to change the color of the frame

Working with Layers

Adding layers in digital photos is frequently done in photo-editing apps on desktop computers and laptops. This involves using separate layers within a single photo. For instance, the background layer can have another layer added to it for text, or for a color technique that can be mixed with the background layer. Each layer within a photo can be edited independently of the others. Layers are not as widely used in photo-editing apps on mobile devices, but PS Express does have some options for this:

Photos that are created in the Mix section are saved there as projects. Each project can be reopened and its individual elements edited again.

1 Tap on the **Mix** button at the top of the Homepage

2 Tap on a photo to open it at full size

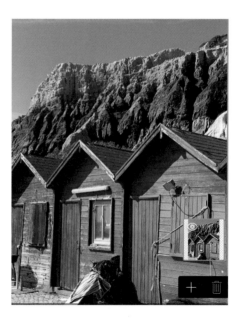

3 Tap on this button on the bottom toolbar to show or hide the Layers panel

4 The Layers panel appears over the photo

5 Tap on this button on the bottom toolbar to access the editing options for the photo. At this point it consists of a single layer

6 Drag the slider at the bottom of the window to change its opacity – i.e. how much of the background shows through

Don't forget

The Edit options in Step 5 include rotating the photo, or flipping it horizontally or vertically. This is applied to the selected layer, regardless of how many other layers there are in the image.

167

Hot tip

Tap on the **Edit** button in Step 5 to edit the photo in the current layer, in the standard Edit mode.

Edit

...cont'd

Hot tip

Tap on a layer in the Layers panel to select it. A selected layer has a colored outline around its thumbnail. When a layer is selected, any editing changes that are made will apply to that layer only.

Don't forget

The Blend options require PS Express Premium in order to apply them, and save the image with the selected effect.

7 Tap on this button on the Layers panel to add another photo. This becomes a new layer in the image

8 Drag the slider at the bottom of the window to change the opacity of the new layer. The greater the opacity, the more the photo in the layer below will be visible

9 Tap on the **Blend** tab to access options for how layers interact with each other

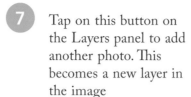

10 Tap on one of the Blend thumbnails to apply it to the currently selected layer. Drag the slider at the bottom of the window to change the amount of the effect

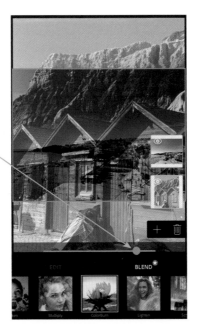

Hot tip

Press on a layer in the Layers panel and drag it above or below the other layers to change the layer order in an image.

11 Press on one of the photos in the main window, and drag it to reposition it in relation to the other layers in the image

Beware

Do not include too many layers, otherwise the final image may look too cluttered and confusing.

12 Tap on this button on the bottom toolbar to include a **Text** layer, and add text as shown on pages 121-123

13 Tap on this button on the bottom toolbar to include a **Stickers** layer, and add stickers as shown on pages 162-163

Making Collages

Photo collages are an excellent way to display two or more photos within an artistic design. The collages can then be shown to family and friends or shared on social media. To create an artistic photo collage:

Beware

Do not include too many photos in a collage, as they will be too small to have an effective impact.

170

1 Tap on the **Collage** button at the top of the Homepage

2 Tap on photos to select them for the collage. Selected photos are denoted by a blue circle with a white check mark inside

3 Tap on the **Next** button

4 The photos are displayed in a default photo-collage grid

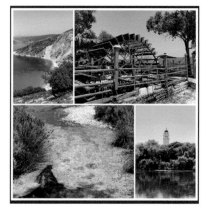

...cont'd

5 Tap on this button on the bottom toolbar to select an aspect ratio for the collage, including for using it on social media sites

For more details about preparing photos for profile and timeline pictures on social media sites, see page 117.

6 Tap on this button on the bottom toolbar and tap on a thumbnail to select a theme for the collage

7 The selected theme is added to the collage

The text elements in a theme can be edited in the same way as editing other text elements – see page 154 for details.

...cont'd

8 Tap on this button on the bottom toolbar and tap on the **Grids** tab to select a new grid design for the collage

Don't forget

If a collage effect has this icon on it, it means that PS Express Premium is required in order to apply it and include it in the final collage.

9 Tap on a grid design to apply it to the collage

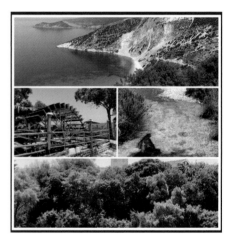

10 Depending on the grid design, the photos may not be displayed as required. Drag within each panel of the grid to move a photo and reposition it

11 Tap on this button on the bottom toolbar to select options for adding, deleting, replacing, or editing photos in the collage

Hot tip

Tap on the **Add** button in Step 11 to select a photo from the photo library and add it to the collage. Once this has been done, the grid will be rearranged accordingly.

12 To delete a photo from a collage, tap on the photo in the grid and tap on the **Delete** button

173

Hot tip

Tap on a photo in the grid and tap on the **Replace** button in Step 11 to replace the selected photo, by choosing one from the photo library. The collage grid will be unaltered.

13 The selected photo is deleted from the collage, and the grid is rearranged accordingly

...cont'd

Don't forget

If a filter is applied to a collage, it is done so to the whole collage, rather than the individual photos within it.

14 Tap on this button on the bottom toolbar to add a filter to the collage, as shown on pages 156-157

15 Tap on this button on the bottom toolbar to add text to the collage, as shown on pages 121-123

16 Tap on this button on the bottom toolbar to add stickers to the collage, as shown on pages 162-163

17 Tap on this button on the bottom toolbar to add a border to the collage, as shown on pages 164-165

11 Sharing and Printing

This chapter shows how to make your photos look their best for sharing with family and friends. It looks at the ways in which photos can be shared, including social media sites, and also shows how to print hard copies with a wireless printer.

Perfecting Social Media Posts

Publishing photos on social media sites such as Facebook, Twitter, Instagram, and Snapchat is now one of the most popular ways of displaying photos. Because of this, and since the photos could have large audiences, it makes sense to try to make the photos look as good as possible. Some options for this include:

- **Taking the best original photos that you can**. It is worth taking some time when you are capturing photos for use on social media, in terms of composition and lighting, to try to ensure that as little editing as possible is required.

- **Cropping**. Most photos benefit from some degree of cropping, to make the main subject stand out more, and this applies just as much to photos that are published on social media sites: people may not always spend that long looking at your photos, so make them as eye-catching as possible.

- **Using filters**. There is absolutely nothing wrong with publishing photos that have had filters applied. This can add an extra dimension to photos and make them stand out, particularly if they are obviously extreme color filters.

The phrase "No Filter", or the hashtag #nofilter, is sometimes used in relation to photos posted on social media sites, to indicate that no editing has been applied to the photos.

Never claim that photos have "no filter" if they have been edited before they are published on a social media site.

Deciding What to Share

With a smartphone or tablet and a social media account it is very easy to post photos for the world to see as soon as they have been taken. This has advantages in terms of speed and ease of use, but there can be a downside to this too. Some points to consider before you share your photos:

- Be selective. Just because you can post hundreds of photos on social media it does not mean that you should. It is better to have a smaller number of good-quality photos rather than just flooding your social media sites with as many photos as you can. Take some time to edit photos so that they are looking their best, and pick the best ones for family and friends to see. Quality wins over quantity every time.

- If you are going on vacation, don't post photos on social media while you are away: this is like giving criminals an open invitation to come and burgle your home, since it is likely to be empty. It may be difficult to resist, but wait until you get back home to show the world your vacation photos.

- Be careful of photos published on social media sites where sensitive information may inadvertently be in the background, such as a debit or credit card on a table behind you when you are taking a selfie. Information such as this can be used by fraudsters to try to access your bank account, and it can also be used as part of the jigsaw when identity fraud is being undertaken.

- Don't feel pressurized into publishing photos of something just because someone else is doing so. It can be better to try to be a bit more unique in terms of your social media photographic output, so your photos will stand out more and have a greater impact.

- If you are publishing photos that include other people's children, even if you are related to them, ask the parents or guardians for permission. Not everyone wants to have an online photographic record of their children, and you should be sensitive to these concerns.

- Never publish any inappropriate photos that could cause offence and could later be used against you. If you are in doubt about any photos, don't post them.

Beware

People can copy photos from social media sites so they can still be available even if you delete them from a social media site.

Adding a Watermark

One area of concern that some people have when they are posting photos on social media sites is that their photos may be copied and reproduced without their permission. It is relatively easy to copy photos from social media sites, but if you are worried about them being used by other people, a watermark can be added before they are uploaded to a social media site, so that they cannot be reproduced without the watermark. To do this:

Don't forget

Watermarks require PS Express Premium in order to apply them and save them in photos.

1 Open a photo to which you want to apply a watermark

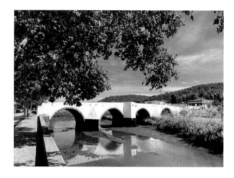

Don't forget

For the Android version of PS Express, the Share options are accessed from this button.

2 Tap on the **Share** button on the top toolbar

3 Tap on the **Watermark** button in the **Save & Share** dialog box

Watermark

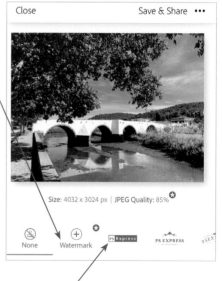

Beware

Do not make watermarks too large or too prominent, otherwise they will detract from the photo itself.

4 Tap on one of the options here to apply a preset watermark to the photo

...cont'd

5 The watermark is placed on the photo. Drag it to one of the black dots on the photo to reposition it

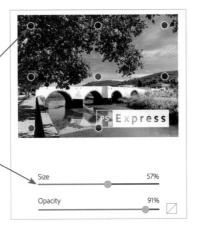

6 Drag these sliders to change the size of the watermark and its level of opacity

| Size | 57% |
| Opacity | 91% |

The lower the opacity level, the fainter the watermark will be.

7 Tap on the **Add Image** button or the **Add Text** button to add these items as watermarks

🖼 Add Image

T Add Text

8 For text, enter the required text and tap on the **Save** button

Edit Text

This is my photo

Save Cancel

9 The text is added as the watermark. Reposition it, if required, by dragging it to one of the black dots, and alter the size and opacity by dragging the sliders as in Step 6

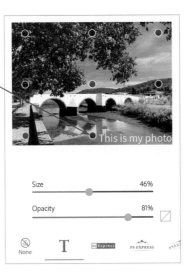

This is my photo

| Size | 46% |
| Opacity | 81% |

None T PS Express PS EXPRESS PSEX

Resizing When Sharing

Digital photos are created with small, colored dots known as pixels. The greater the number of pixels in a photo, the greater the resolution of the photo: this is calculated by multiplying the pixels in the photo according to the height and width. So if the dimensions of the photo are 3024 x 4032 pixels, the resolution is just over 12 million pixels, also known as 12MP (megapixels). Pixels also contribute to the overall file size of a photo and, in general, the greater the number of pixels, the larger the file size. When printing photos, it is preferable to have as high a resolution as possible. However, when sharing photos via smartphones and tablets it can be better to have a smaller resolution (smaller file size) so that it is more efficient to send it via email, social media, or a messaging app. In photo-editing apps it is possible to reduce the file size of a photo before sharing it. To do this:

Hot tip

The file size of digital photos can also be reduced by editing the image quality. When sharing photos, the quality can be reduced without resulting in a noticeable deterioration in the visual quality of the photo. To reduce the photo quality, tap on the **JPEG Quality** option in Step 1 and drag the **Quality** slider at the bottom of the panel.

JPEG Quality: 85%

1 Open a photo and access the **Save & Share** dialog box as shown on page 178

2 Tap on the **Size** option (the current photo size is displayed, in pixels)

Size: 3024 x 4032 px

3 Tap on one of the **Image Resize** options to create the photo at a new size, ready for sharing

Sharing to Social Media

Photos can be shared to a range of social media sites, if you have an account with the selected site. To do this:

1 Open a photo and access the **Save & Share** dialog box as shown on page 178

Don't forget

When you first try to share a photo to a social media site you will be prompted to give PS Express access to the relevant social media account. Tap on the **Continue** button and then log in to the account so that PS Express can be linked to it.

2 Swipe up the dialog box and tap the required social media sites to **On** (the button becomes blue)

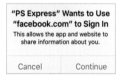

"PS Express" Wants to Use "facebook.com" to Sign In
This allows the app and website to share information about you.

Cancel Continue

3 Tap on the **Save & Share** button Save & Share

4 If you have linked to your social media account (see tip), a notification appears when the photo has been uploaded

Your photo has been uploaded to Twitter

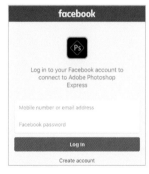

facebook

Log in to your Facebook account to connect to Adobe Photoshop Express

Mobile number or email address

Facebook password

Log In

Create account

5 The photo appears on the selected social media site

Nick Vandome @nickvandome · 43s
Made with adobe.com/go/psx

Sharing to WhatsApp

Messaging apps are a popular way to share photos, and one of the most widely used is WhatsApp:

You must have an active WhatsApp account in order to share photos in this way.

1 Open a photo and access the **Save & Share** dialog box as shown on page 178

2 Swipe up the dialog box and tap on the **WhatsApp** option

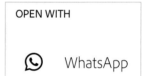

3 Tap on the **WhatsApp** icon

4 Select a recipient within WhatsApp, and tap on the **Next** button

Next

5 The photo is inserted into a WhatsApp message. Add any text as required, and tap on the **Send** button

Sharing via Email

Email is another way to share photos with family and friends, directly from a smartphone or tablet. To do this:

1 Open a photo and access the **Save & Share** dialog box as shown on page 178

2 Swipe up the dialog box and tap on the **Email** option

3 The photo is added within a new email window

4 Add a recipient for the email in the **To** box, and any body text as required. Tap on the **Send** button to send the email

Don't forget

The title for the email is inserted automatically when the photo is shared. The text for the title changes each time a new photo is shared in this way.

Setting up Wireless Printing

Printing your own photos can sometimes be a frustrating and time-consuming business. However, a smartphone or tablet can send photos directly to a printer without the need to physically connect to the printer. To set up a wireless printer:

Hot tip

Companion apps for wireless printers can be found by searching in your device's app store. The app may not have the exact same name as your printer, but it should have the same manufacturer's name. Printer apps can also be used for managing a wireless printer, such as monitoring ink levels.

1 Buy a wireless printer (make sure it has wireless capability) and turn it On. Access the **Wireless** settings from the control panel

2 Access the **Wireless Setup Wizard** settings on the printer's control panel and follow the step-by-step process, including selecting your wireless network and entering the password for the router to connect the printer to the network

Using an app

Some wireless printers have a companion app that can be used to add the printer to a smartphone or a tablet:

1 Download the wireless printer's companion app

2 Open the app and tap on the **Set Up a New Printer** option, and follow the step-by-step instructions for setting up the new printer

Using Wireless Printing

Once a wireless printer has been set up, photos can be sent directly to the printer. To do this:

1 Open a photo and access the **Save & Share** dialog box as shown on page 178

2 Tap on the **Print** button

3 Tap on the **Select Printer** button

4 Tap on a printer to select it, and tap on the **Printer Options** button

5 Make any selections for the photo, including the number of copies and color or black and white, and tap on the **Print** button

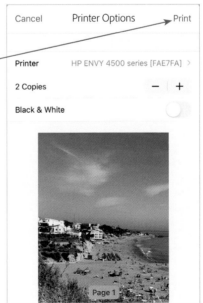

In the Apple version of PS Express, the **Print** option is located in the section that is accessed from the **More** button in the Save & Share dialog box. In the Android version, the Print option is accessed from the **Print** button under the **More** heading.

Photo kiosks in retail outlets can also be used for printing photos directly from a smartphone or tablet. This can be done by connecting the device using a USB cable or by using Bluetooth.

Sharing On Your Device

The sharing function can also be selected to use photos in a variety of ways on your smartphone or tablet. To do this:

1 Open a photo and access the **Save & Share** dialog box as shown on page 178

page 178

Don't forget

For the Android version of PS Express, the options in Step 3 are accessed from the **Others** button. There are different options for Android and Apple devices.

• • •

Others

2 Swipe up the dialog box and tap on the **More** option

OPEN WITH

Message

Messenger

• • • More

3 Select one of the options for sharing the photo on your device. These include: saving a copy of the photo; assigning the photo to a contact in your address book; using it for the Home screen image; using it for the Lock screen image; or saving it to another folder on your device